Autumn, 2006, from "Down East"

The Colors of Fall

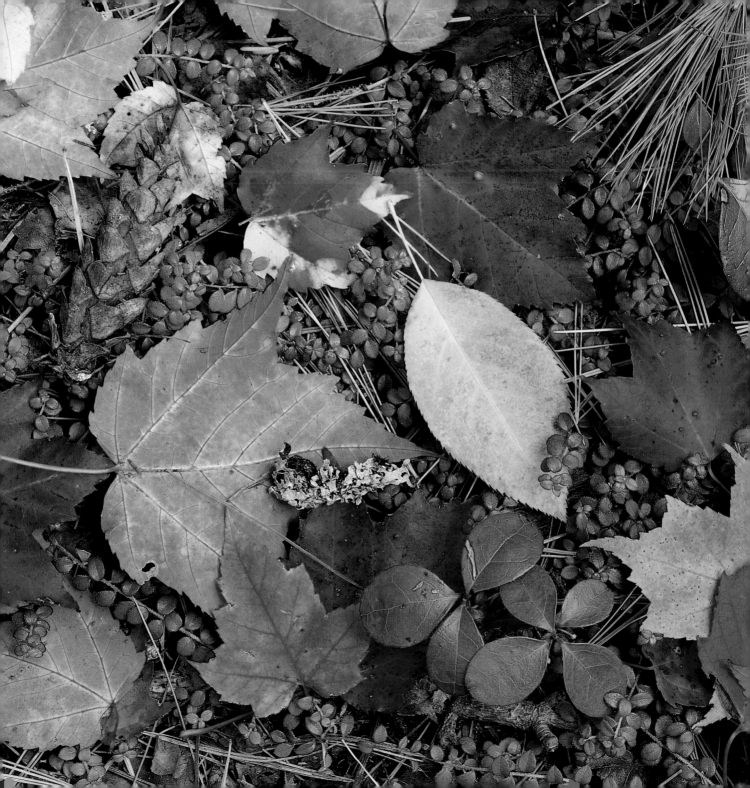

The Colors
of Fall

*A Celebration of New England's
Foliage Season*

JERRY AND MARCY MONKMAN

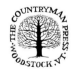

THE COUNTRYMAN PRESS
WOODSTOCK, VERMONT

Library of Congress Cataloging-in-Publication Data
Monkman, Jerry.
The colors of fall : a celebration of New England's foliage season /
Jerry and Marcy Monkman. — 1st ed.
p. cm.
ISBN 0-88150-542-0
1. Fall foliage—New England. 2. Leaves—Color—New England.
3. Fall foliage—New England—Pictorial works. 4. Leaves—Color—New
England—Pictorial Works. I, Monkman, Marcy. II. Title.
QK121.M66 2003
779'.34'0974—dc21 2003048592

Jacket design by Peter Holm, Sterling Hill Productions
Interior design by Susan McClellan
Maps by fahertydesign.com

Published by The Countryman Press, P.O. Box 748, Woodstock, Vermont 05091
Distributed by W.W. Norton & Company, Inc., 500 Fifth Avenue,
New York, NY 10110

Printed in Spain by Artes Graficas Toledo
10 9 8 7 6 7 5 4 3 2 1

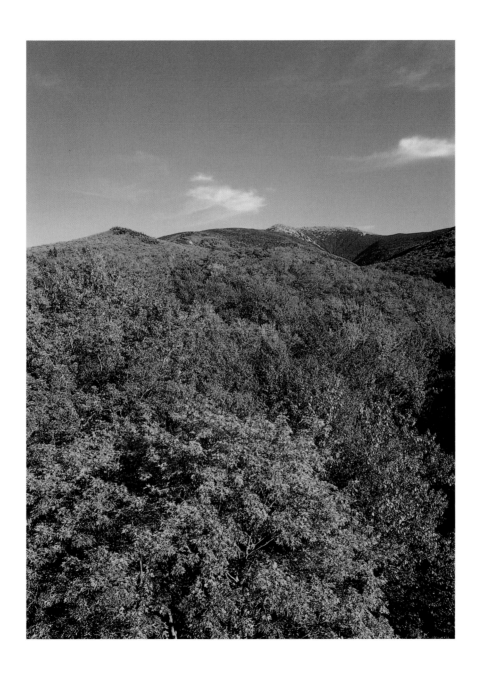

Mount Lafayette,
New Hampshire

INTRODUCTION

EVERY SEPTEMBER AND OCTOBER, several million people flock to New England simply to look at leaves. It is a notable event in an era when cell phones and the Internet define our pace of life, and when extreme sports and adventure travel lure more and more people into the outdoors. Yes, some of these millions come to scale granite walls or paddle a frothy stretch of white-water, but most come to walk and sit, and to stare at leaves so brilliant that they are not described as red, yellow, and brown, but scarlet, gold, and bronze. During the peak of this color display, it is easy to inadvertently hold your breath while taking in the sight of a landscape seemingly on fire, where the only smoke is a wisp of early morning fog rising from a small mountain pond.

In this book, we offer our photographs as a celebration of fall in New England's wild places, where the climate, forests, and topography combine to create some of the most colorful fall foliage in the world. This celebration provides an intimate look at a season whose beauty goes deeper than the hillsides of red and yellow that you can see from the windows of a tour bus on Vermont's Route 100 or New Hampshire's Kancamagus Highway. It is a beauty that is not just "out there," but "in there," waiting to be discovered by those who venture into the landscape. For us, fall in New England is about stunning views from bald granite domes, but it is just as much about rocky forest trails covered in a carpet of red maple leaves, and rivers reflecting the colors of sugar maples and taking on the look of molten gold.

In the following pages, we will briefly talk about how nature created New England's fall colors with volcanoes and glaciers, chlorophyll and carotene; but primarily we leave you to explore the season through our images. We feel privileged to have spent more than a dozen fall seasons making these photographs, and even more privileged to be able to share them with you now.

OPPOSITE

Fall colors,
Baxter State Park,
Maine

7

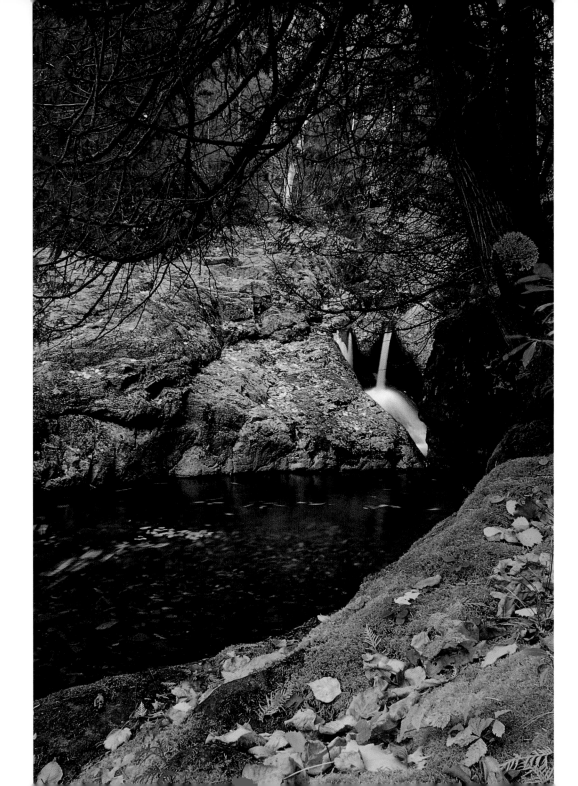

*An unnamed
cascade, Howe
Brook, Maine*

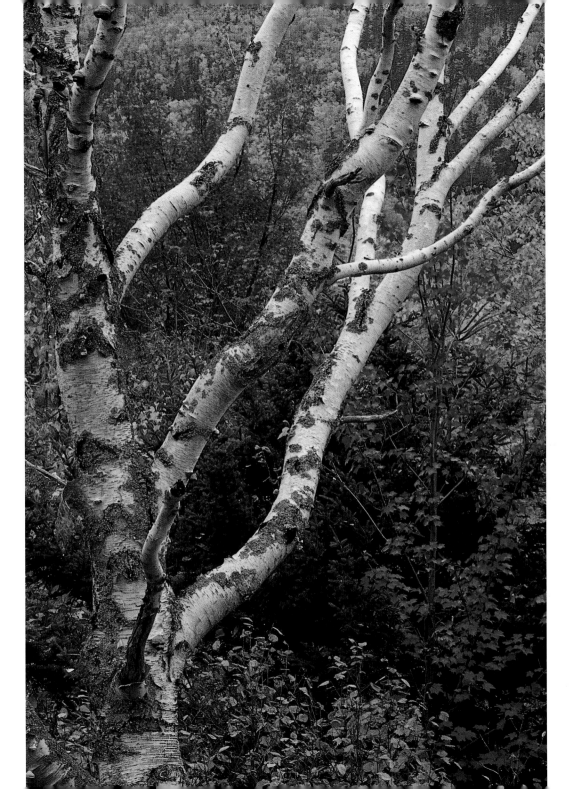

Gray birch, Baxter

State Park, Maine

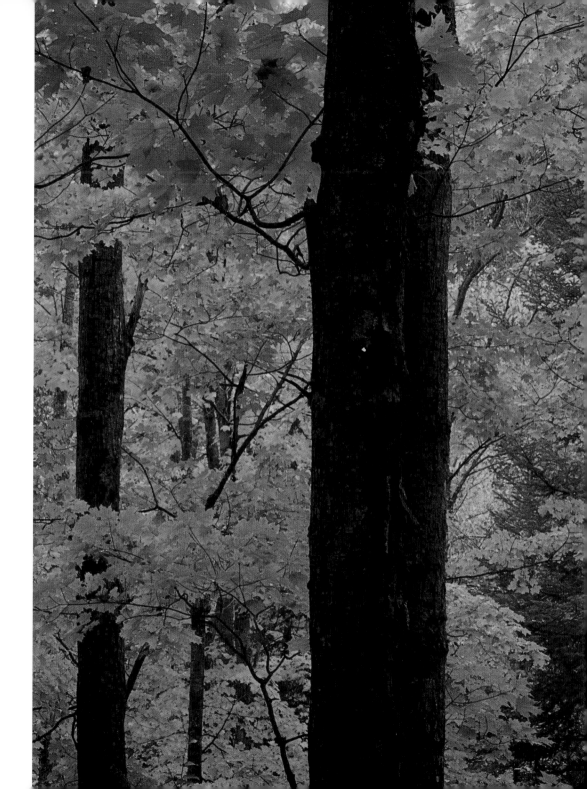

*Northern
hardwoods, Green
Mountain
National Forest,
Vermont*

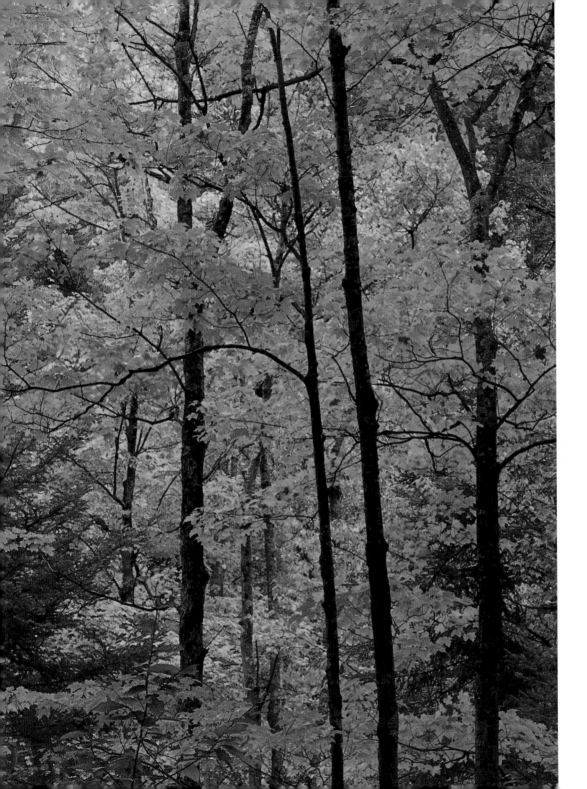

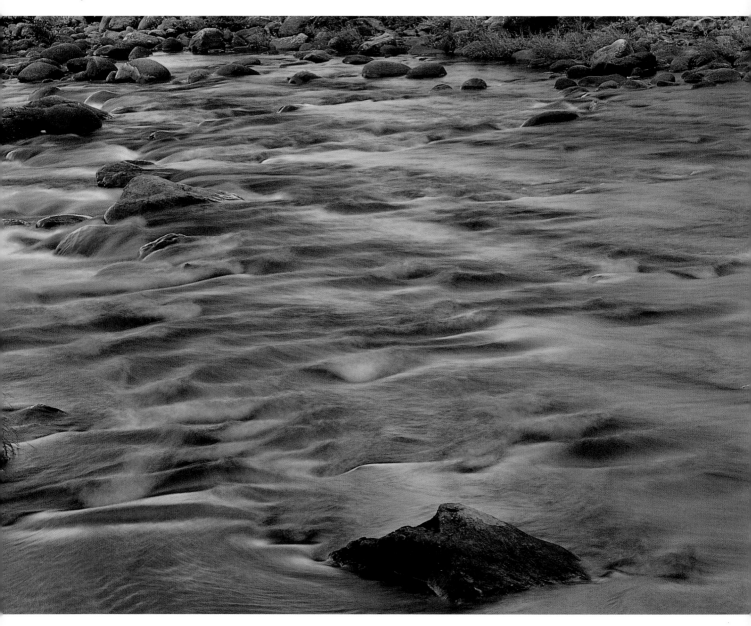

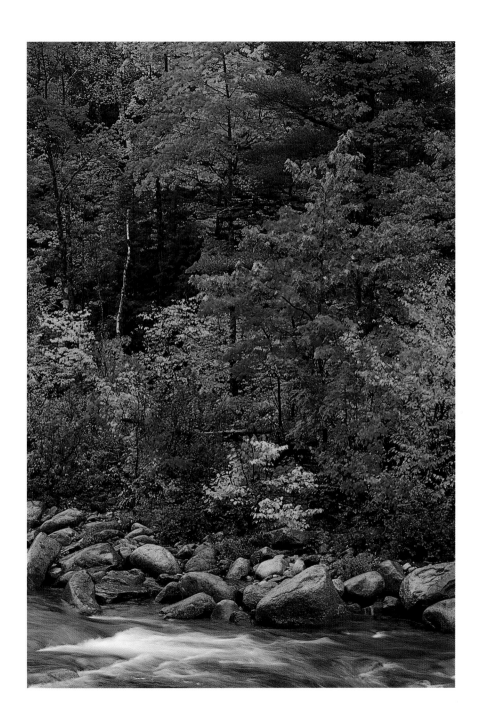

LEFT

Swift River, White

Mountain

National Forest,

New Hampshire

OPPOSITE

West River

reflections,

Jamaica, Vermont

RIGHT

Maple leaves,
Maine

OPPOSITE

Forest Road,
Acadia National
Park, Maine

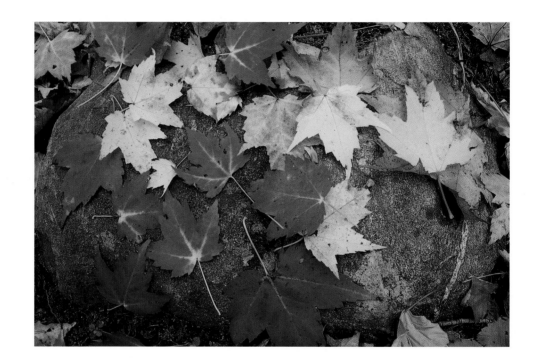

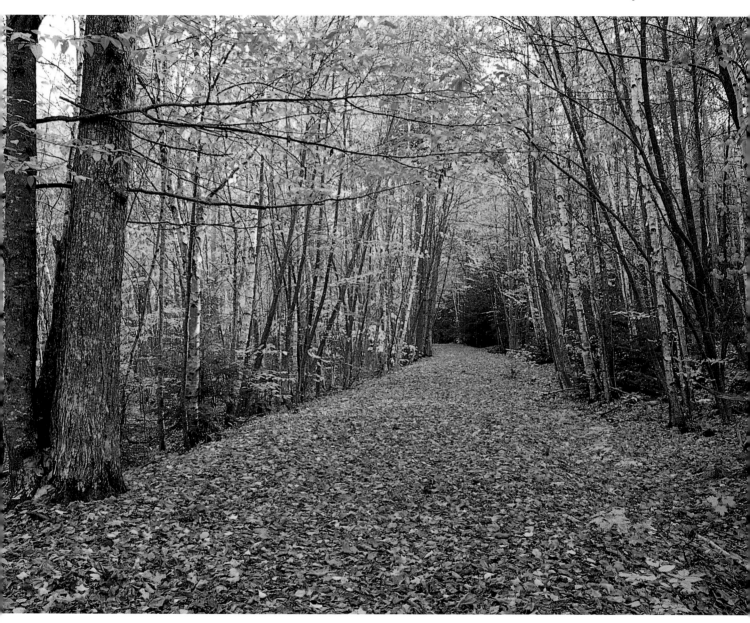

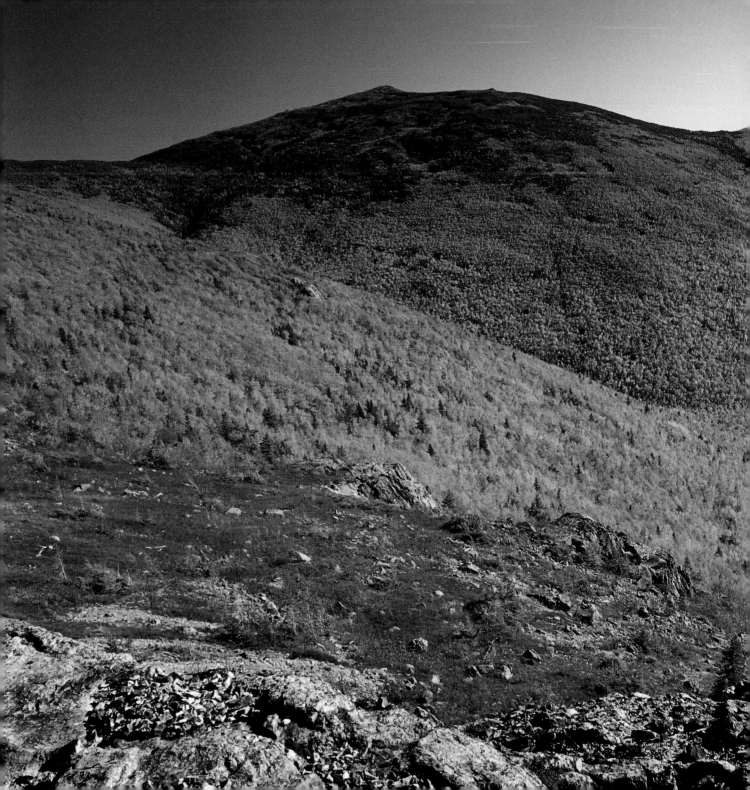

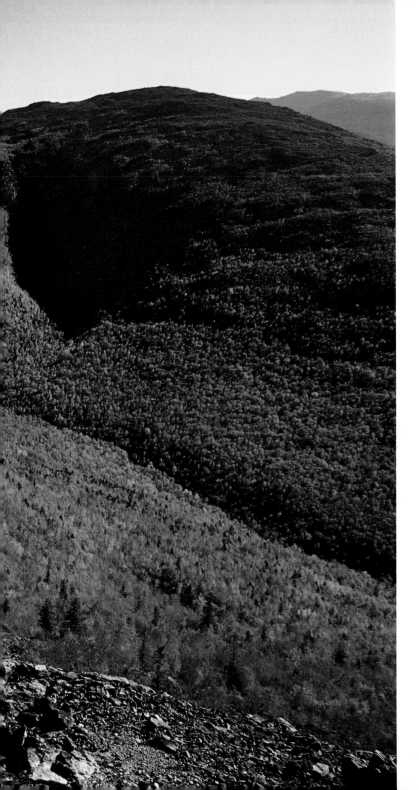

The Colors
of Fall

Early October on
Traveler
Mountain, Maine

17

SHAPING THE NEW ENGLAND LANDSCAPE

NEW ENGLAND'S FALL COLOR DISPLAY is popular with visitors from around the world for two simple reasons. First, New England's forests are made up of a diversity of tree species that turn a variety of colors in fall; and second, these forests are prominently on display on hillsides and mountains, making leaf-peeping a relatively effortless activity. This fortunate intersection of topography and biology is the result of hundreds of millions of years of geologic forces shaping the land and the ability of eastern forests to adapt to change. In fact, New England forests in their current form have only been around for a few thousand years.

New England's mountains were created during a series of events that took place between 500 million and 250 million years ago. During this time, the eastern edge of North America repeatedly crashed into other pieces of the Earth's crust from Europe and northern Africa. This crunching of continents caused much of New England to be lifted into high mountain ranges, many thousands of feet higher than the current Appalachians, much like the Himalayan Mountains are currently being lifted by the collision of India with Asia.

As the continents were pushed together and then later pulled apart, volcanic activity proliferated above and below New England's surface. Evidence of this activity is still visible today. The large granite domes in New Hampshire and Maine are the result of molten magma bubbling up within the ancient Appalachians, while the Ossipee Mountains in central New Hampshire are the remains of an ancient volcano. The entire Connecticut River valley south of Vermont and New Hampshire is a rift valley, where lava repeatedly flowed as tectonic forces attempted to rip eastern New England into the newly formed Atlantic Ocean.

OPPOSITE

White pines and maples, Chocorua Lake, New Hampshire

18

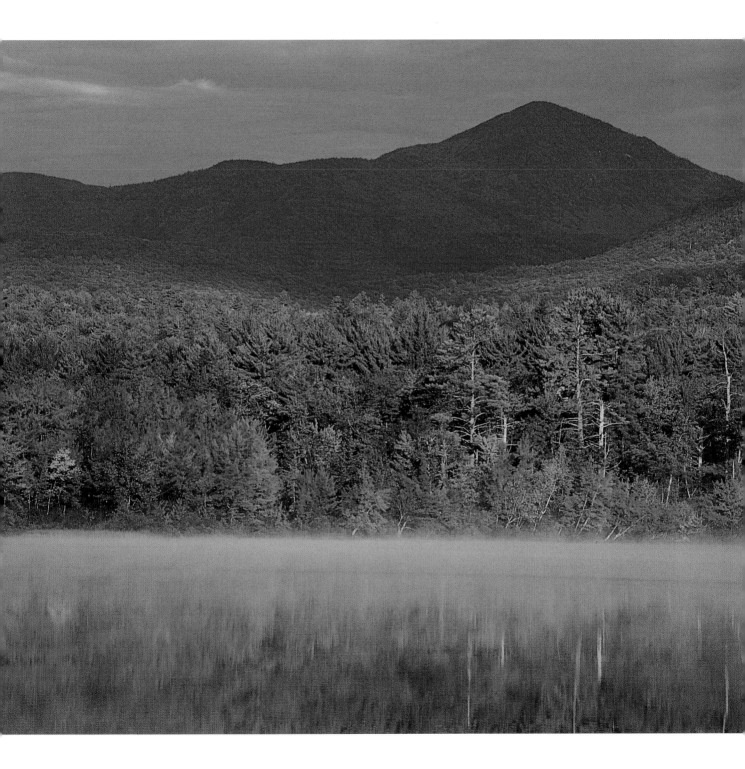

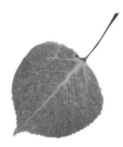

The tall mountains and deep valleys of prehistoric New England were slowly eroded over millions of years by water, wind, and ice. During the last three million years, the New England landscape has been subject to a series of long ice ages. The most recent ice age began about 100,000 years ago and ended only 13,000 years ago. Glaciers, several thousand feet thick, covered all of New England and the ice flowed over the land toward the sea, scraping and grinding the earth as it traveled. The ice rounded off the tops of our mountains, carved deep U-shaped valleys like Crawford and Franconia Notches, and left round, bowl-shaped cirques on high peaks like Mount Washington and Mount Katahdin. It also rolled earth and rocks into low hills called drumlins, while rivers flowing under the ice piled sediment into curvy ridges of rubble known as eskers. Big chunks of ice left by retreating glaciers eventually melted and left ponds known as kettle holes.

When the ice finally retreated, New England was left a treeless expanse of tundra. As the climate warmed, conifers like fir and spruce colonized the first forests, to be followed later by white pine and hemlock and deciduous trees like sugar maple, paper birch, and American beech. By about 3,000 years ago, New England's forests had a mix of species similar to today, with boreal forests of spruce and fir in the far north, oak-hickory forests in the south, and northern hardwood forests in between.

Of course most of the forests in New England today do not date back 3,000 years. Much of the region's forest was cleared during the eighteenth and early nineteenth centuries for agriculture. In New Hampshire and Vermont, a large percentage of forest was cleared for sheep pasture during the first half of the nineteenth century during a boom in the domestic wool market. After the Civil War, many farmers abandoned New England for more fertile ground to the west. Forests that were not farmed, such as those in the White Mountains and northern Maine, were logged extensively during the nineteenth century and

continue to be cut today. The majority of our forests are new growth, having grown up to fill clear-cuts and abandoned fields. Hardwoods and white pines tend to be the first trees to colonize these treeless spaces. This is good news for foliage watchers, as northern hardwood forests have replaced conifers in many northern valleys and mountainsides, bringing fiery fall foliage displays to scenes that previously remained green throughout the year.

Considering what was cut, it is remarkable how much forest there is in New England. For example, during the wool boom, New Hampshire was covered by less than 50 percent forest. Today, about 85 percent of the state is covered by trees. Similar forest growth has occurred in the other New England states.

Dawn from North Kinsman, White Mountain National Forest, New Hampshire

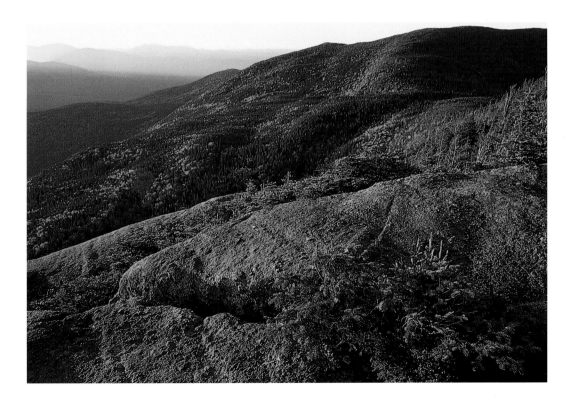

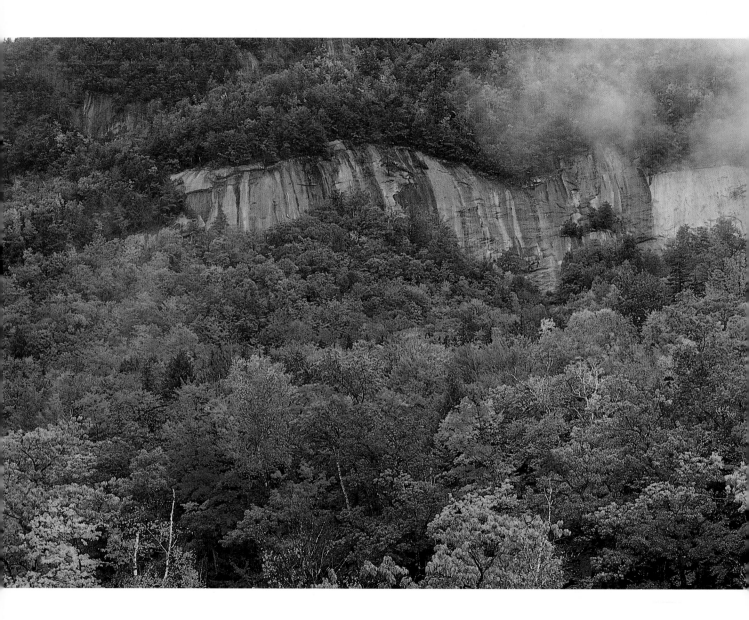

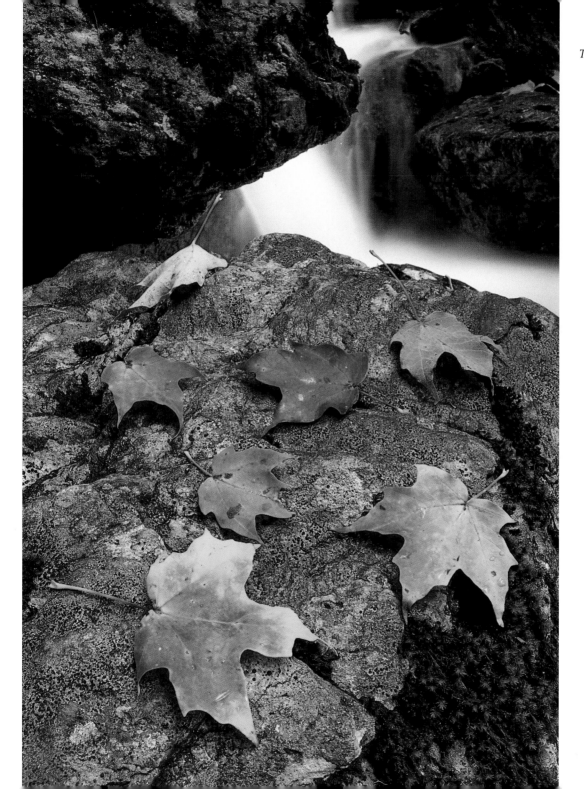

LEFT

*Money Brook
Falls, Mount
Greylock State
Reservation,
Massachusetts*

OPPOSITE

*Northern
hardwoods at
peak, White
Mountains, New
Hampshire*

23

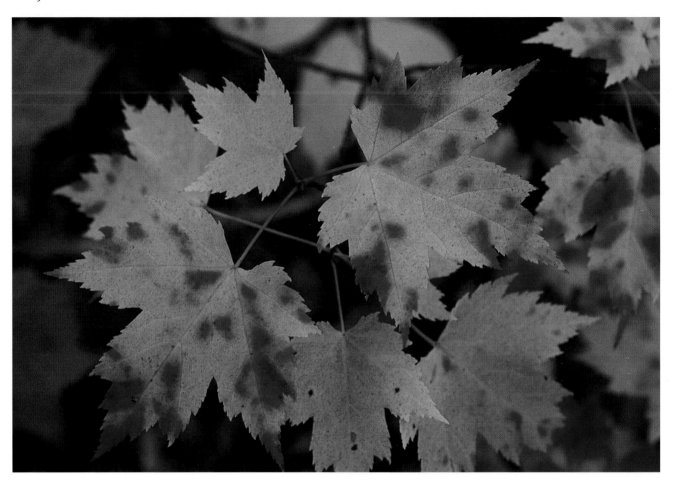

Maple leaves in

transition

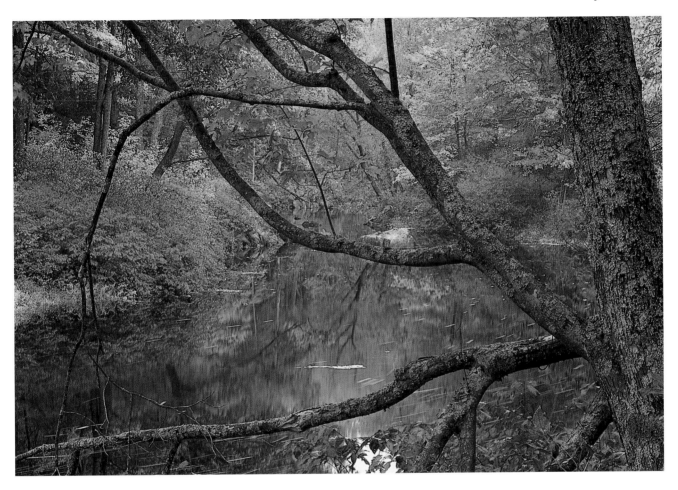

Fall on the
Lamprey River,
Durham, New
Hampshire

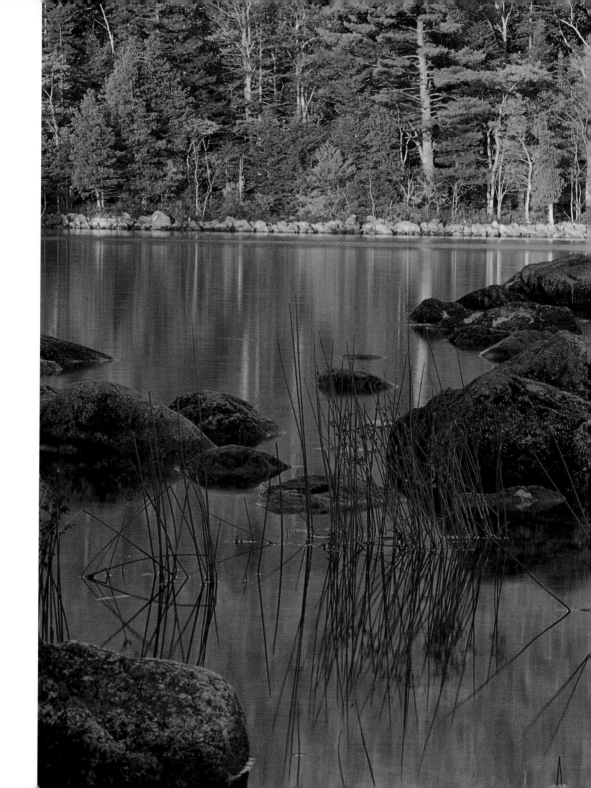

Boulders and

reflections,

Jordan Pond,

Acadia National

Park, Maine

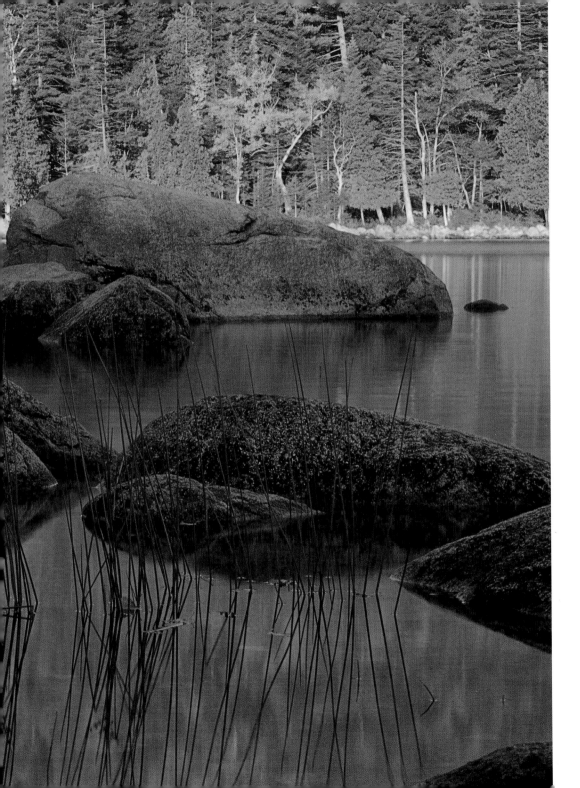

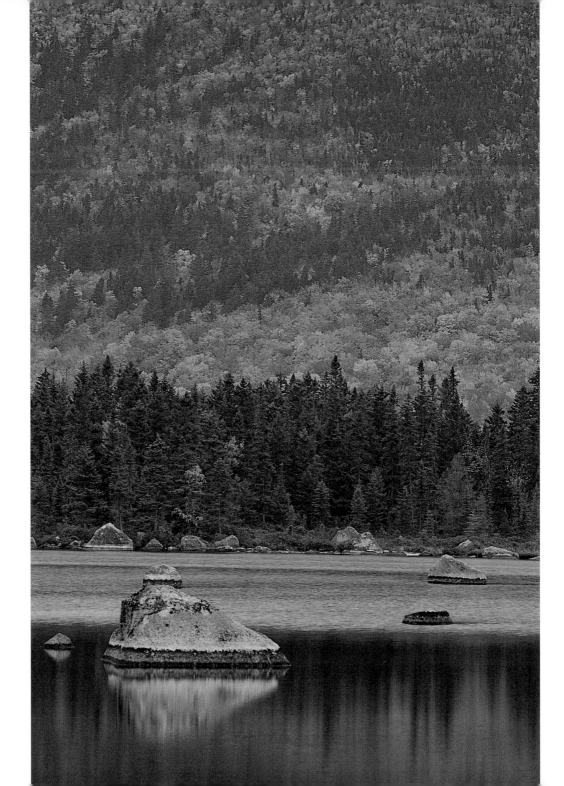

RIGHT
—————
Russell Pond,

Baxter State Park,

Maine

OPPOSITE
—————
Across Lower

South Branch

Pond, Maine

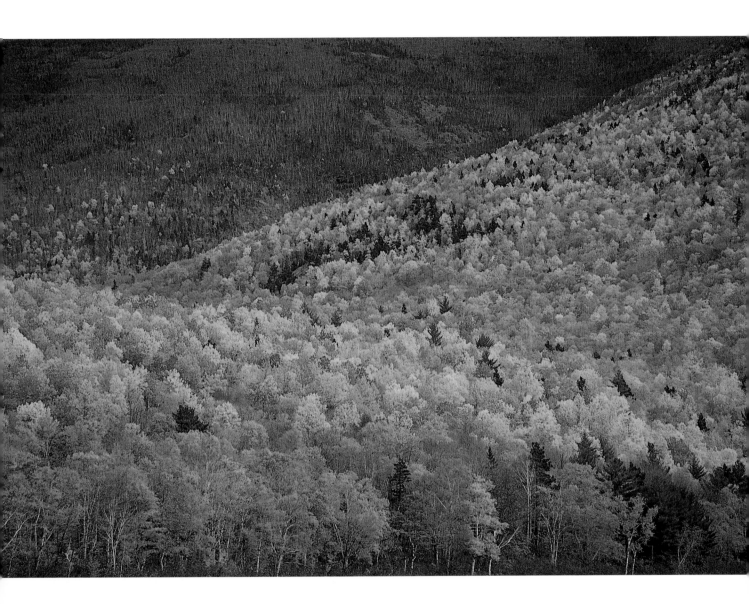

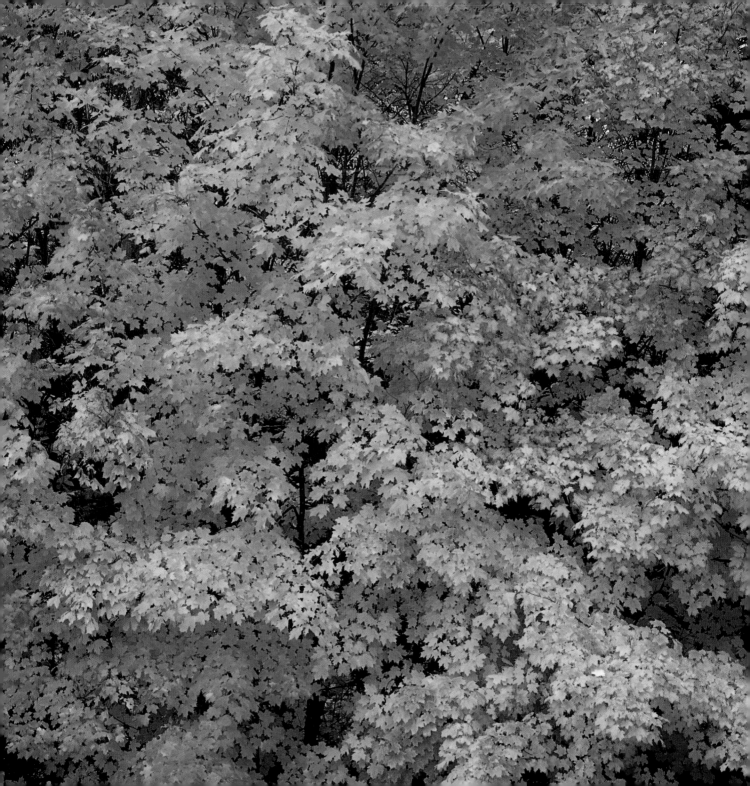

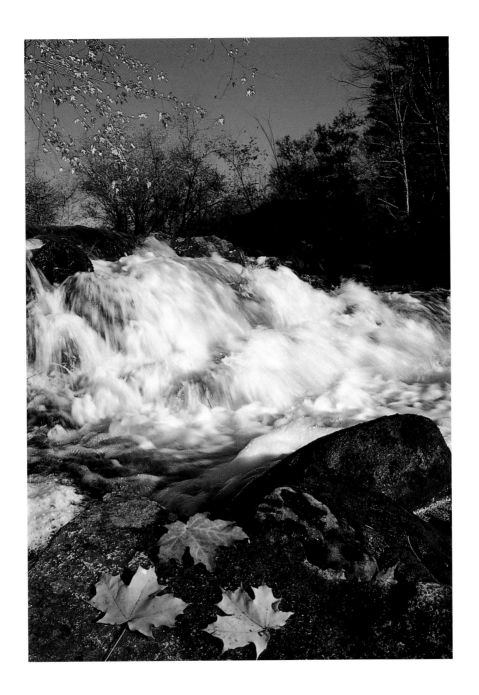

LEFT

Maple leaves and

Wadleigh Falls,

Lee, New

Hampshire

OPPOSITE

Sugar maples

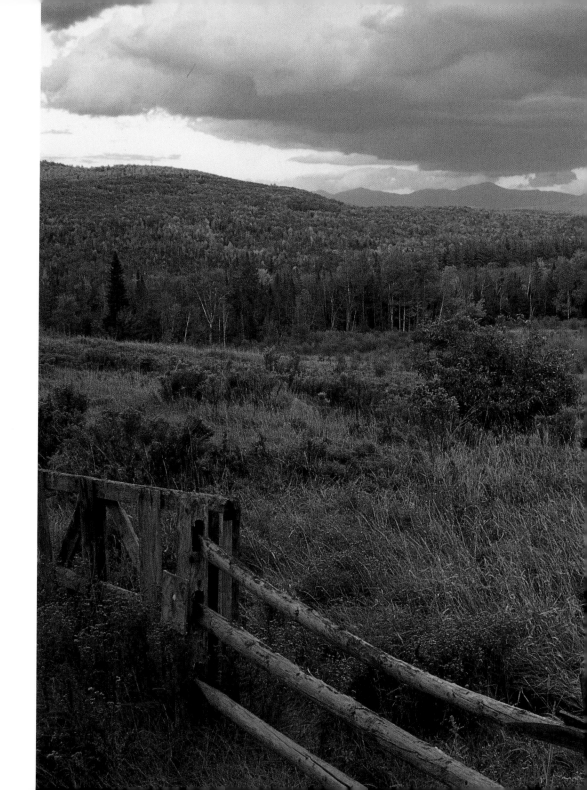

The Colors
of Fall

Sugar Hill,
White Mountains,
New Hampshire

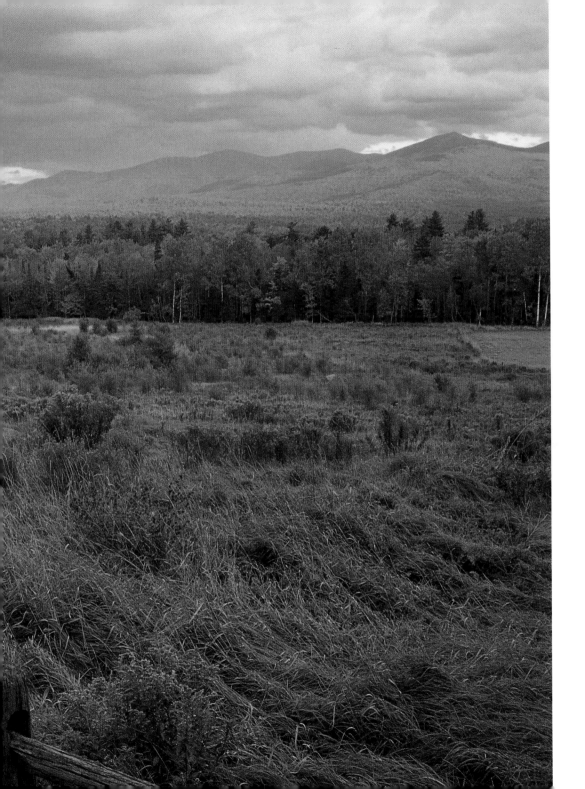

RIGHT

Carriage Road
Gatehouse, Acadia
National Park,
Maine

OPPOSITE

Maples and
fences,
New Milford,
Connecticut

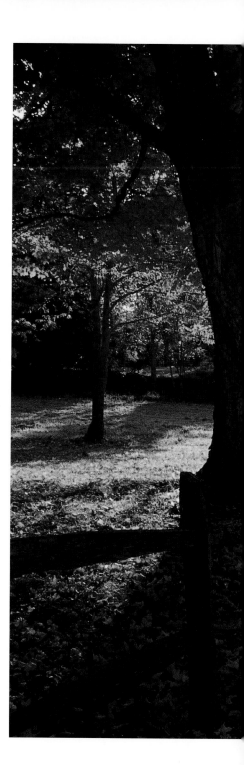

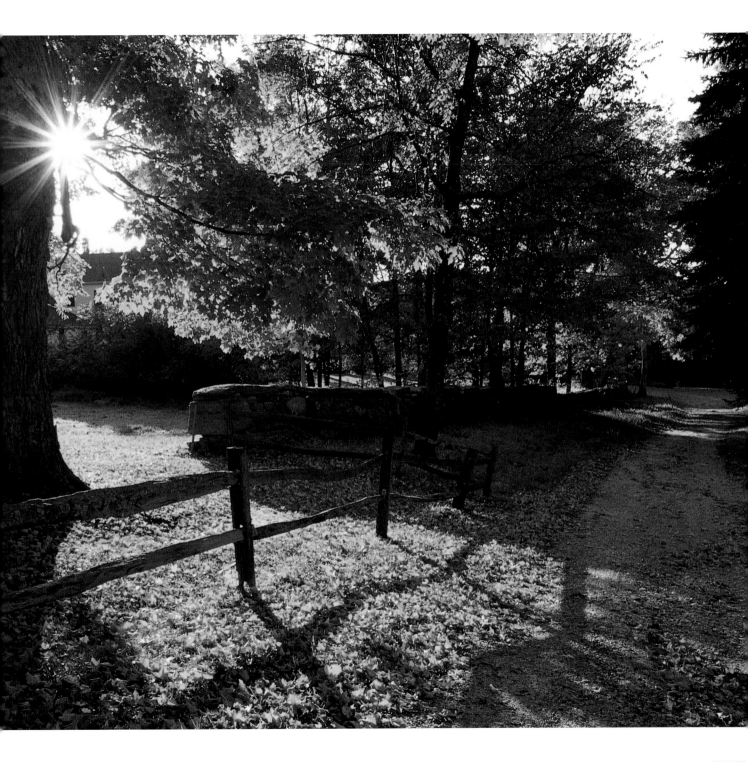

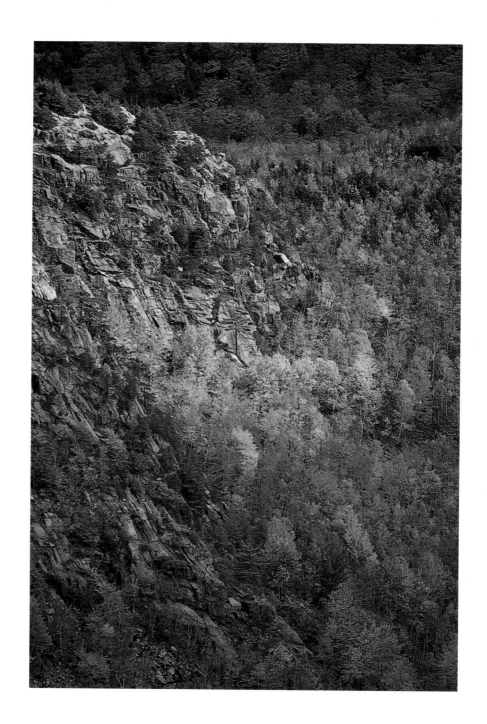

RIGHT

Northern hard-
woods and cliffs,
The Bubbles,
Acadia National
Park, Maine

OPPOSITE

Aspen leaf on fir
branch, Island
Pond, Vermont

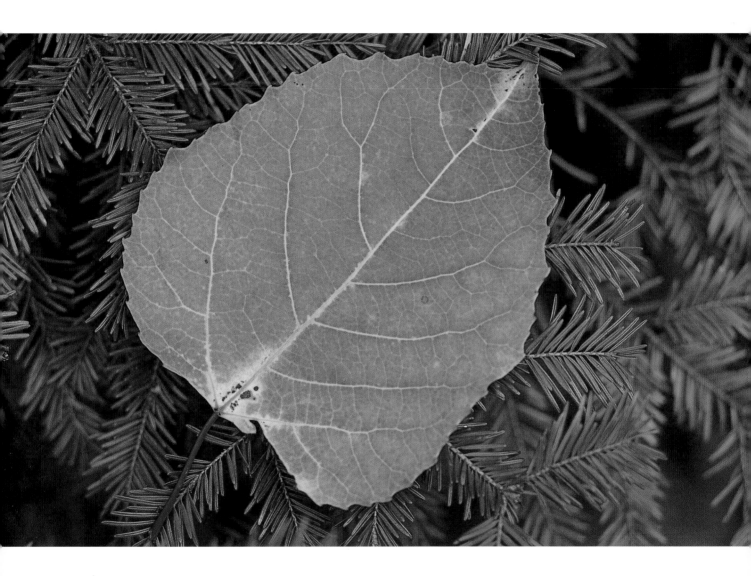

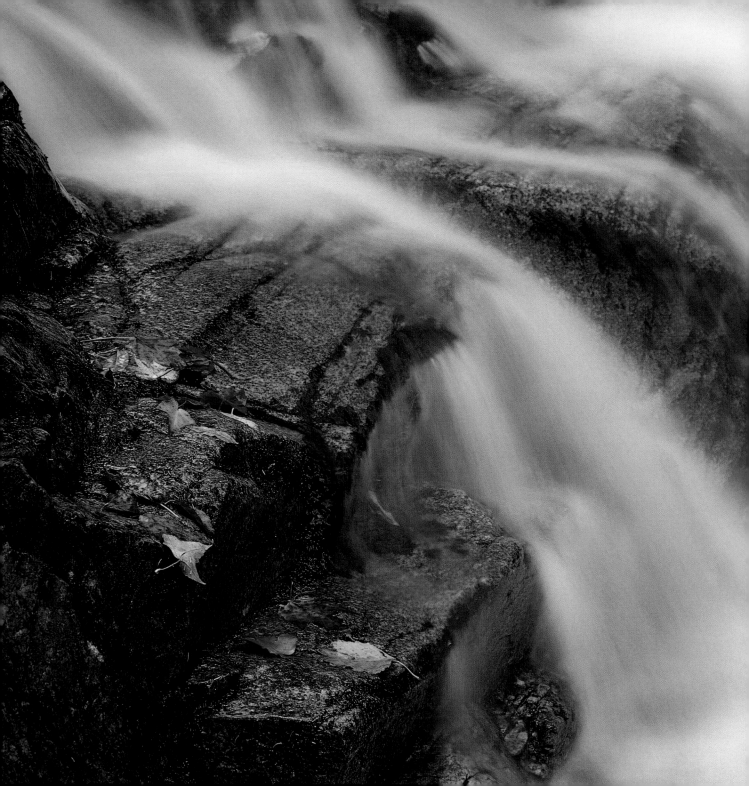

Waterfall,
Crawford Notch,
White Mountain
National Forest,
New Hampshire

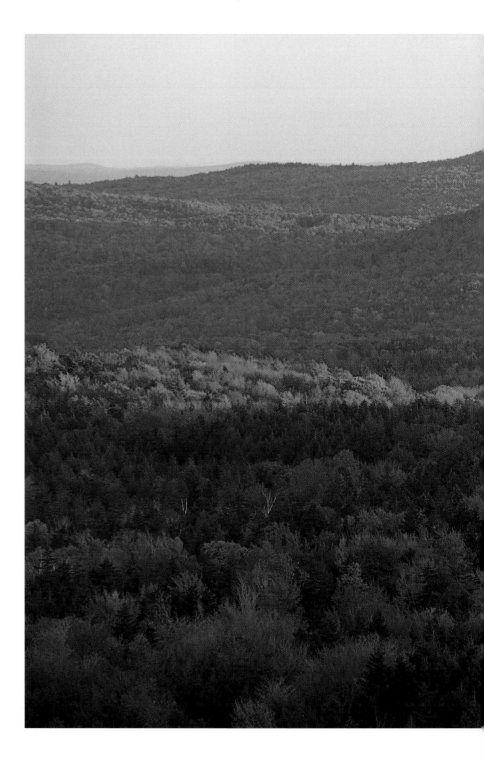

Dusk in southern

Vermont

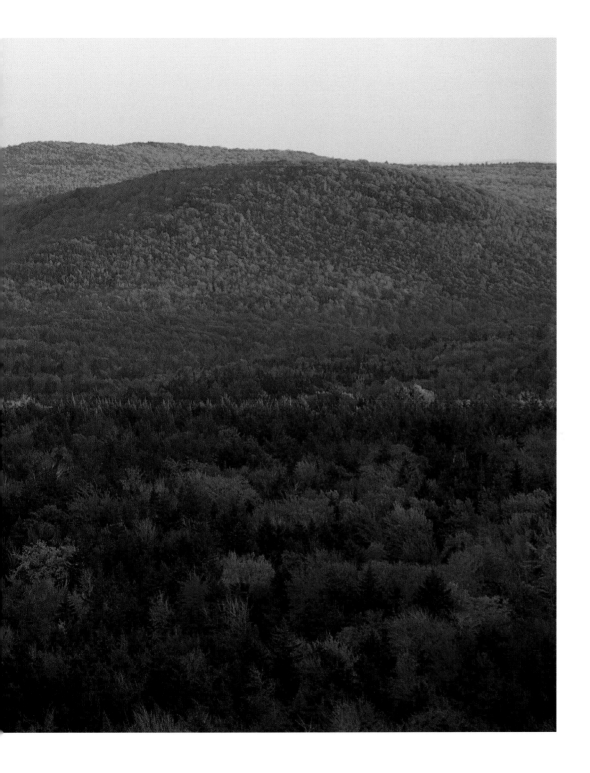

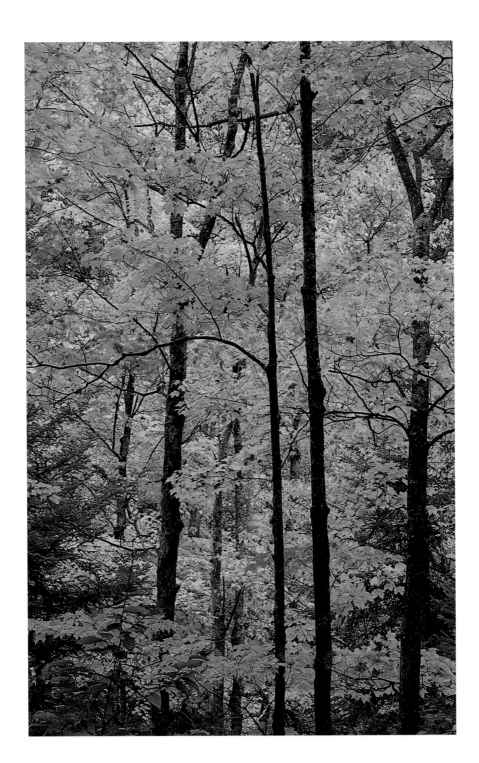

Texas Falls Trail,

Vermont

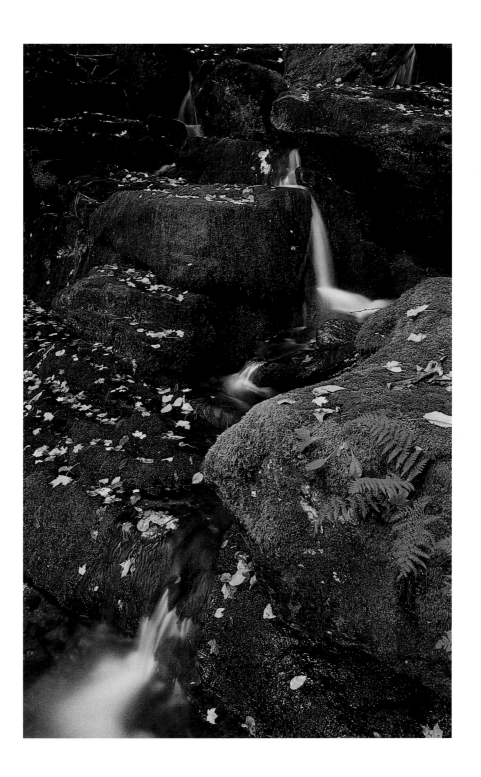

Waterfall,
Abbey Pond Trail,
Vermont

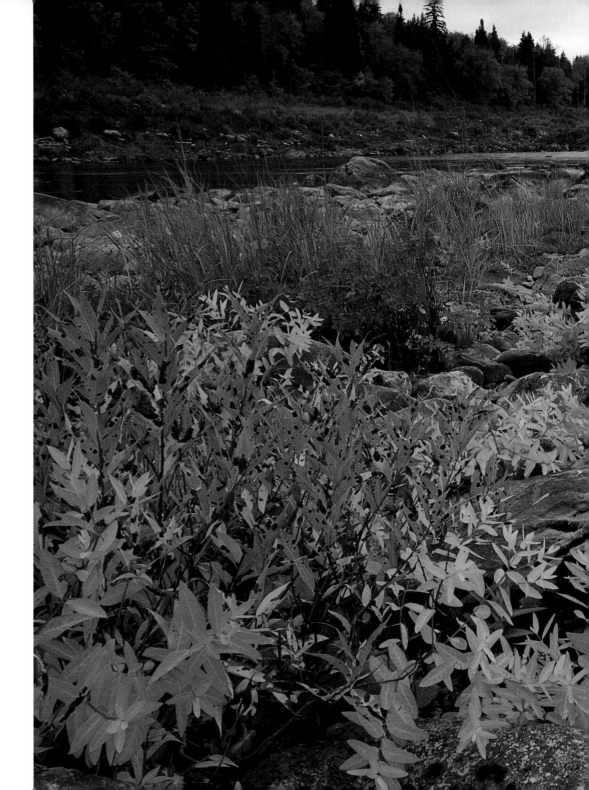

Willows,

St. John River,

Allagash Village,

Maine

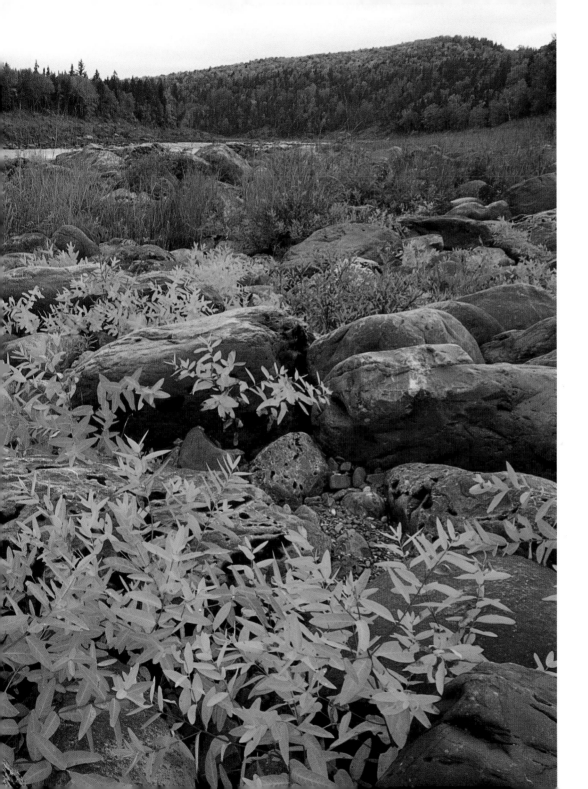

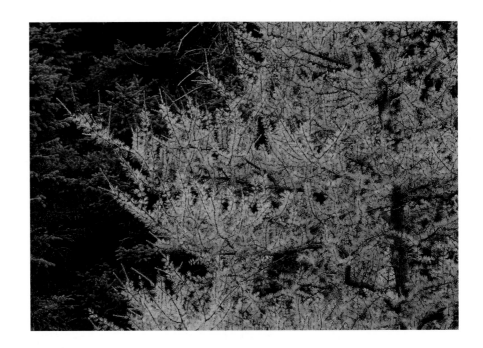

RIGHT

Eastern larch

OPPOSITE

*Silver maples and
boats, Contoocook
River, New
Hampshire*

46

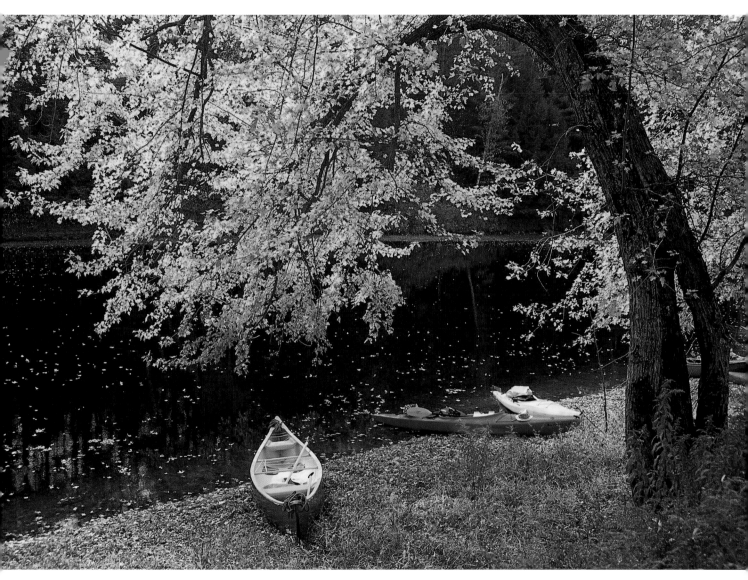

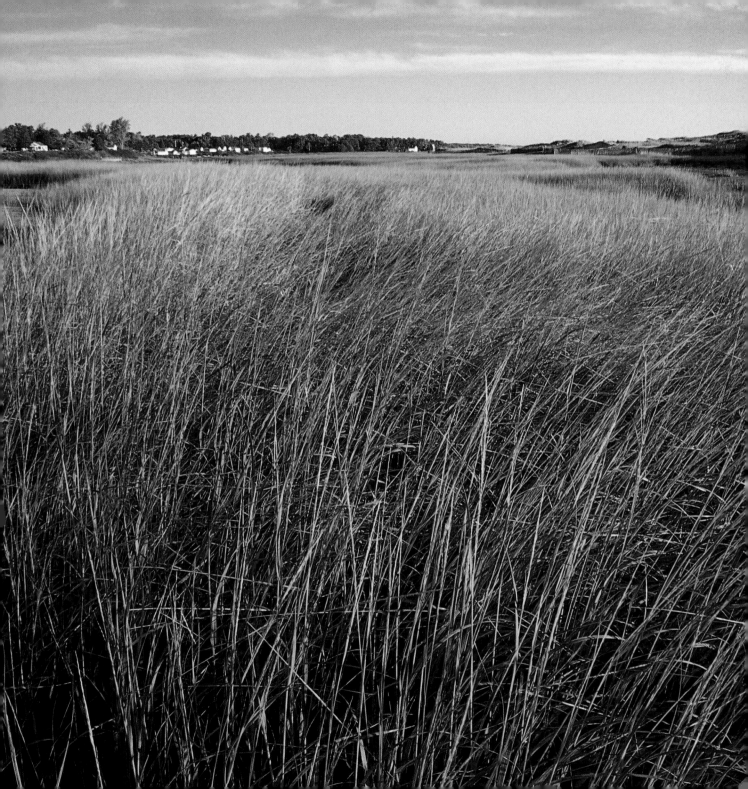

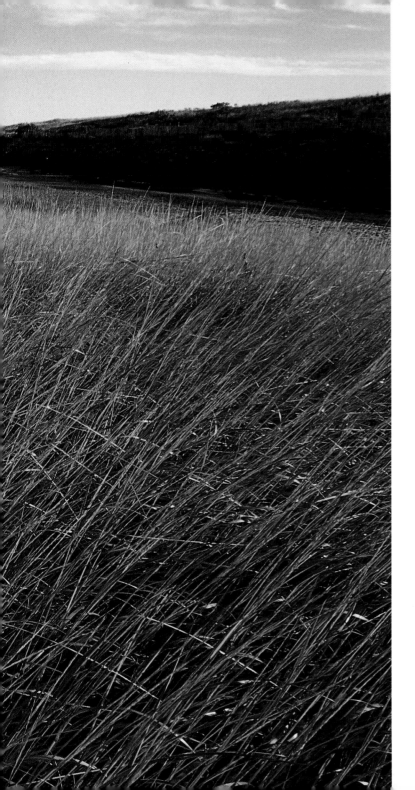

Salt marsh,
Ogunquit, Maine

TODAY'S FORESTS

IF YOU RANDOMLY throw a dart at a map of New England, the odds are pretty good that dart will land on a place covered in forest. And while there are many types of forests in New England, chances are that your dart will land on one of the following three: boreal, northern hardwood, or oak-hickory.

BOREAL FORESTS

In New England, the boreal forest is generally found at elevations above 3,000 feet, except in far northern New England, where it is common at lower elevations. This "spruce-fir" forest has a thick canopy that allows little sunlight to pass through, but enough reaches the understory to permit the growth of shrubs such as mountain maple and sheep laurel, as well as wildflowers such as starflower, twin flower, and wood-sorrel. Paper birch and aspen can also survive in the cold weather of the boreal zone, but they are relegated to populating places where the canopy has been disturbed by storms.

NORTHERN HARDWOOD FOREST: FALL'S PEAK

The northern hardwood forest is a transition forest, the buffer between the vast boreal forest to the north and the oak-hickory forest to the south. Most of New England is part of this buffer zone, as is much of New York and parts of Pennsylvania, the northern Great Lakes states, and southern Ontario. Northern hardwood forests often contain tree species that are more common in a boreal forest, most notably white pine, red spruce, paper birch, and eastern hemlock. They can also be home to species found in oak-hickory forests such as northern red oak and mountain laurel. What defines a northern hardwood forest, however, is a triumvirate of dominant tree species: sugar maple, yellow birch, and American beech.

OPPOSITE

Crawford Notch,
White Mountain
National Forest,
New Hampshire

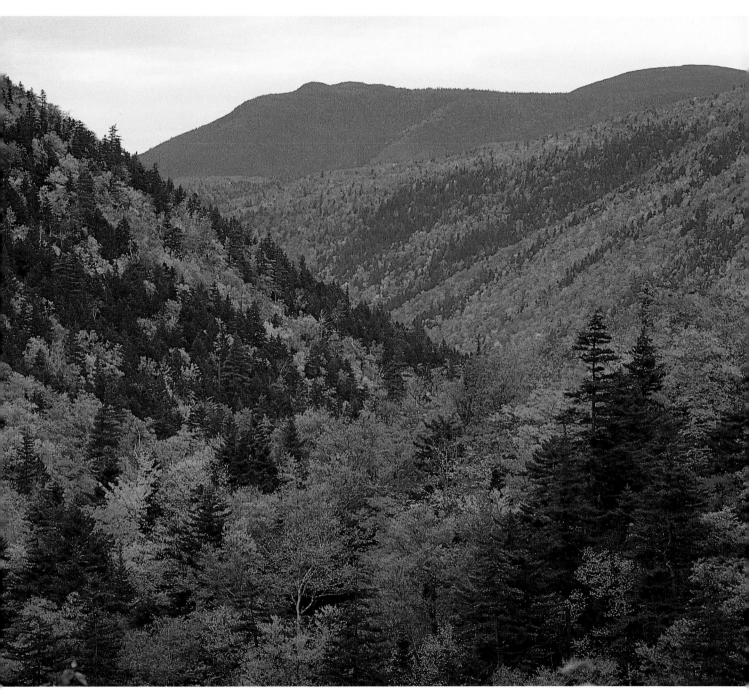

The tall branching trunks of these hardwoods create a much different environment than the dark world of the straight and narrow conifers in a boreal forest. The trees are more spread out and the canopy is higher up, resulting in a brighter, airier forest with a richer diversity of understory species like striped maple and hobblebush taking advantage of all the extra light.

By late September and early October, the bright yellow leaves of birches blend seamlessly with the leaves of beeches, which turn slowly from green to yellow to golden brown over the course of a few weeks. Filling the spectrum between yellow and brown are the spectacular orange leaves of sugar maples. But maples can be a wild card for leaf-peepers. Several factors, including location and weather, affect the color of a sugar maple leaf in the fall, which can vary from yellow to orange to red.

It is the red that makes New England's northern hardwood forest the foliage destination of choice. A mountainside of yellow, orange, and brown will always draw visitors, but throw in a few red sugar maples and some of their red maple cousins, along with a modest grove of dark green hemlocks for contrast, and you have a postcard photographer's dream. This is the classic view of fall foliage season, but it is just as spectacular inside the forest, underneath the colorful canopy, where sunlight is filtered yellow and orange and the day takes on the look of a perpetual sunset. This foliage sunset is nearly as fleeting as a real one however, as rain and wind usually conspire to end the peak of foliage season after only a few days of glory.

THE OAK-HICKORY FOREST: SCENE OF AUTUMN'S LAST STAND

While the region's most famous foliage show ends with the dropping of leaves in the northern hardwood forest, autumn's beauty continues to linger in southern New England's oak-hickory forests, where a slightly longer growing season encourages a large variety of trees to hold on to their leaves for a week or two

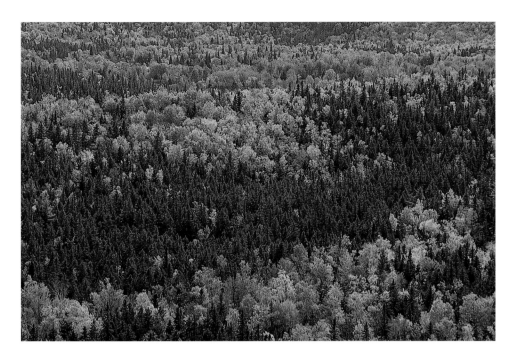

Hardwoods and
conifers, Baxter
State Park, Maine

longer than their counterparts to the north. For many, foliage season ends after Columbus Day weekend, but visitors to places like the western highlands of Connecticut know better. Like much of southern New England, these rolling hills that rise up from the Housatonic River take on a golden hue in late October as several species of oaks and hickories turn yellow and brown, waiting as late as early November to drop their leaves.

An excursion into the oak-hickory forest also reveals plenty of red fall foliage that is not evident when looking at the hills from a distance. Highbush and lowbush blueberry and mapleleaf viburnum often fill the understory of an oak-hickory forest, and these shrubs turn scarlet and pink in fall, creating a scene where a yellow forest canopy contrasts sharply with a red-carpeted forest floor. And while the yellow and brown hickories and oaks dominate the canopy, other tree species also add their colors to the mix, including red maples, quaking aspens, and American elms.

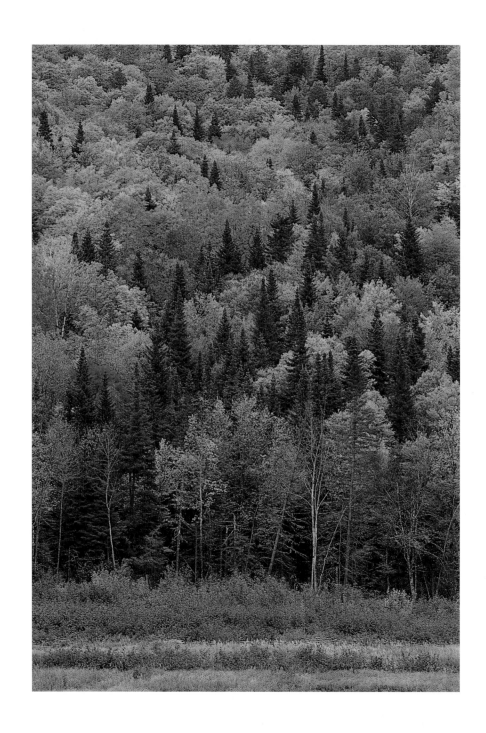

Near Fort Kent,
Maine

Tarn Trail, Acadia
National Park,
Maine

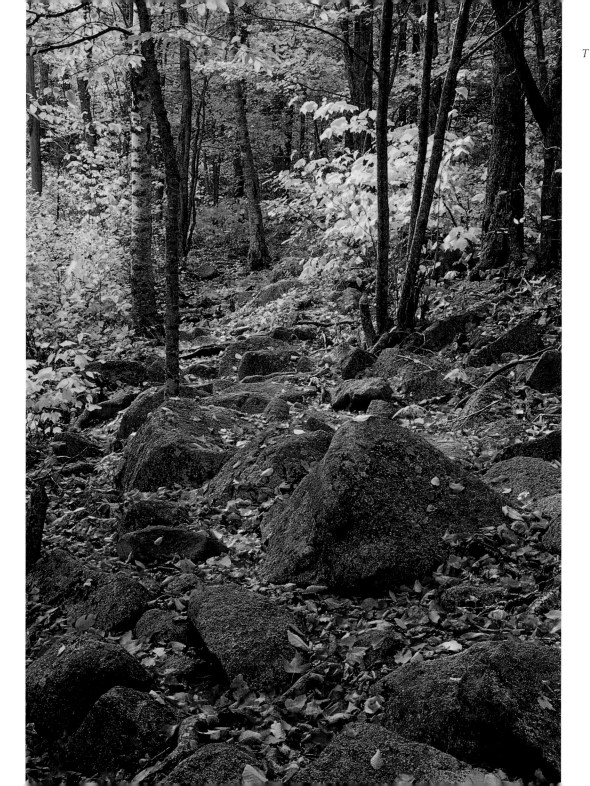

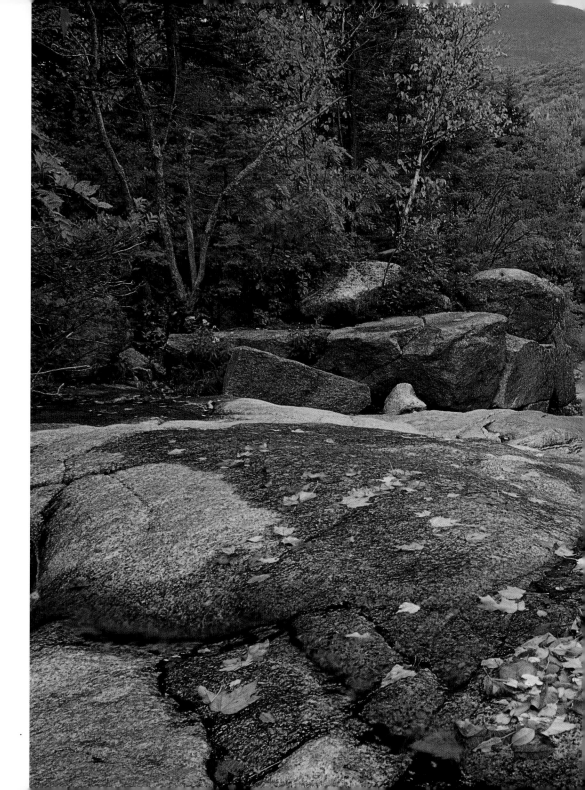

From the top of
Zealand Falls,
New Hampshire

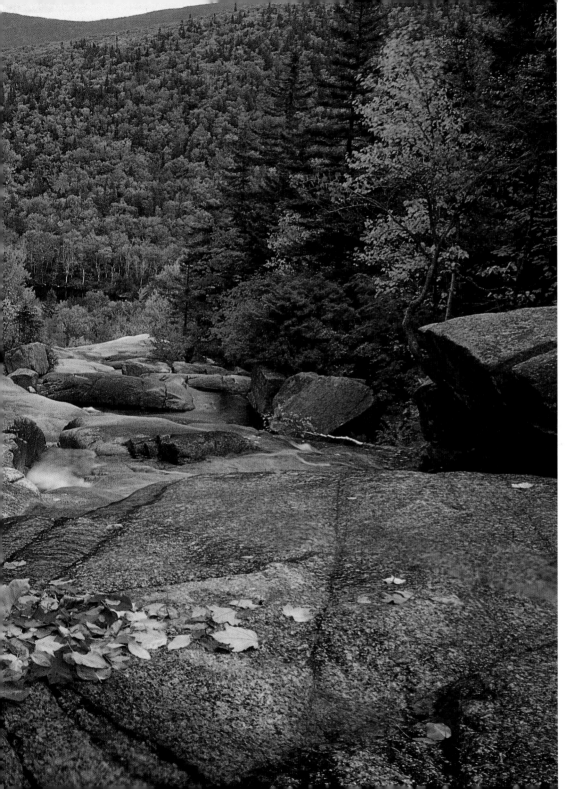

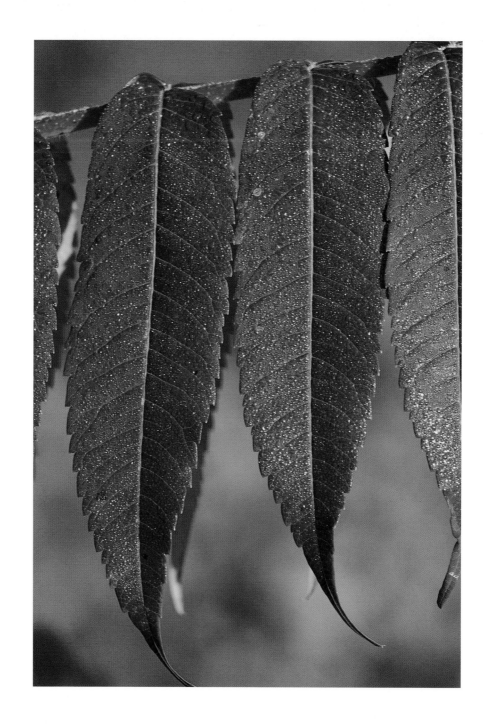

RIGHT
————
Sumac

OPPOSITE
————
Stone wall,
Farmington,
New Hampshire

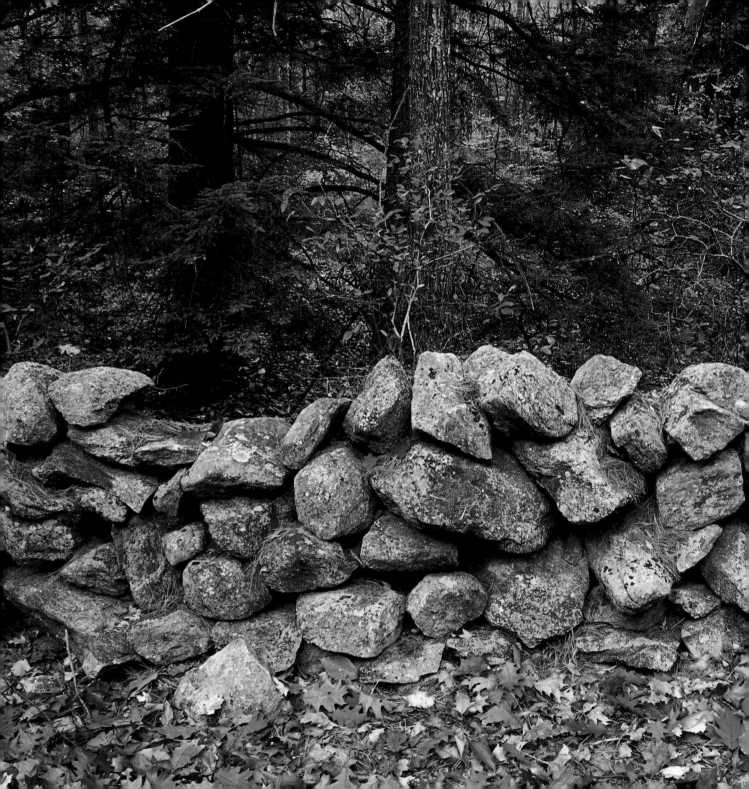

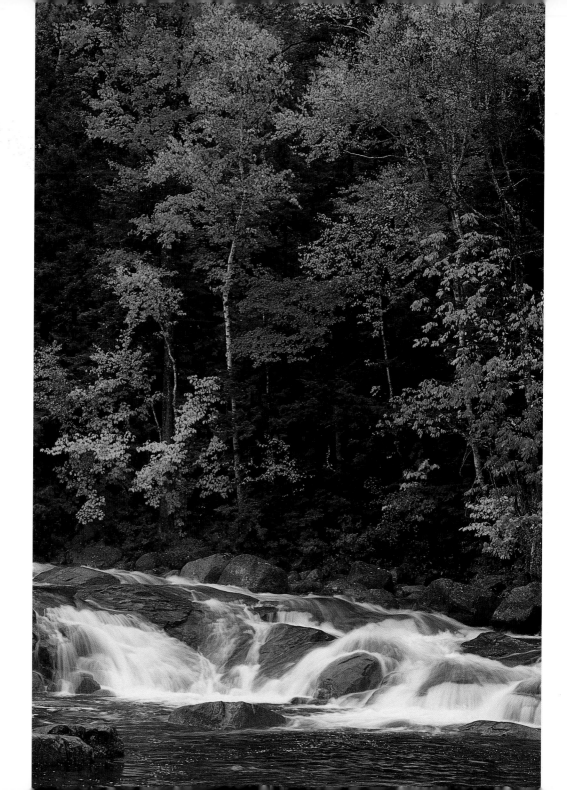

*Lower Falls,
Swift River, New
Hampshire*

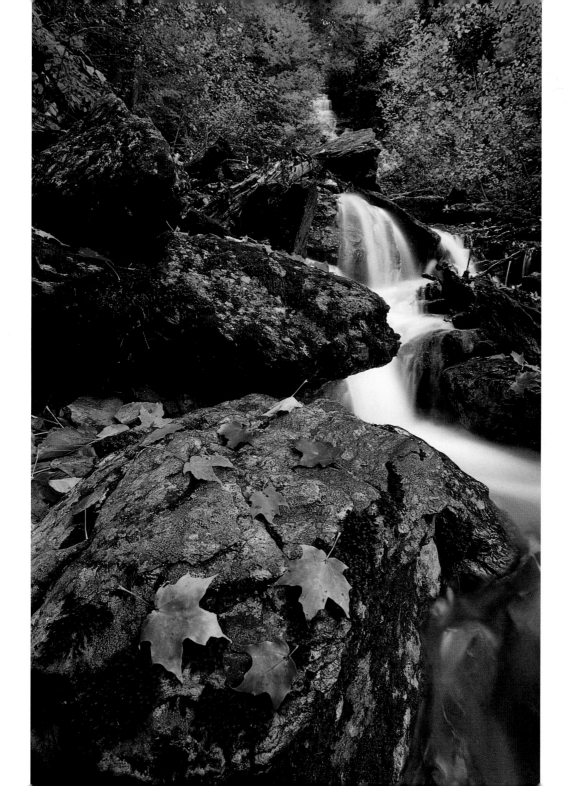

*Sugar maple
leaves and
waterfall,
Massachusetts*

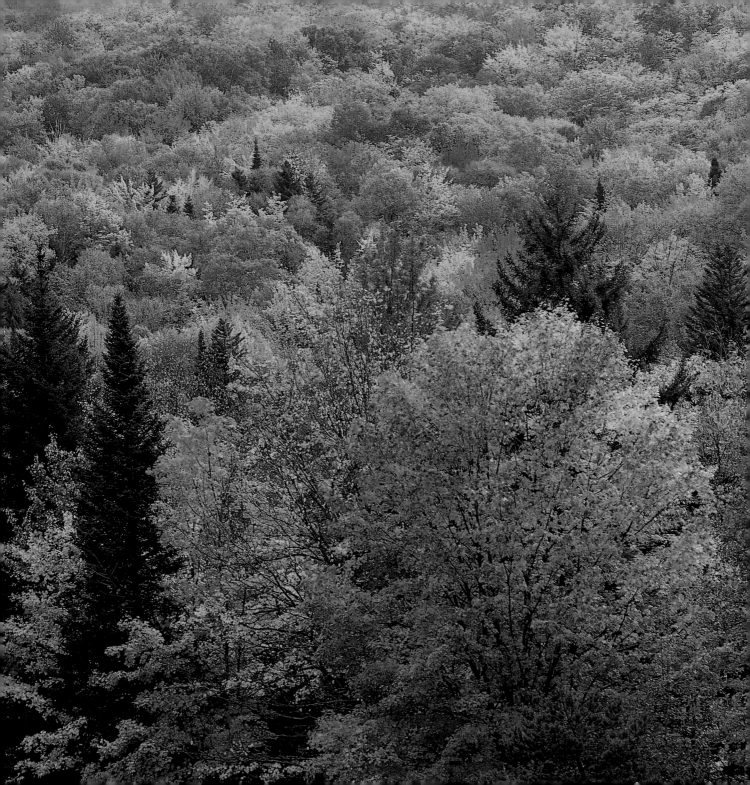

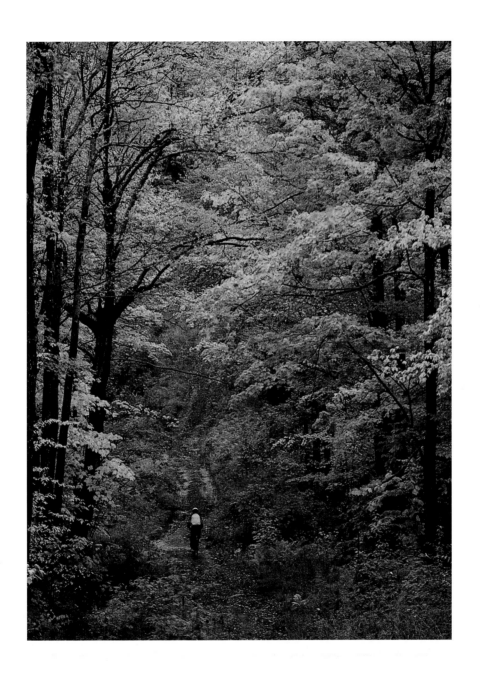

Mountain biking on an old logging road, Wardsboro, Vermont

OPPOSITE

Twin Mountain, New Hampshire

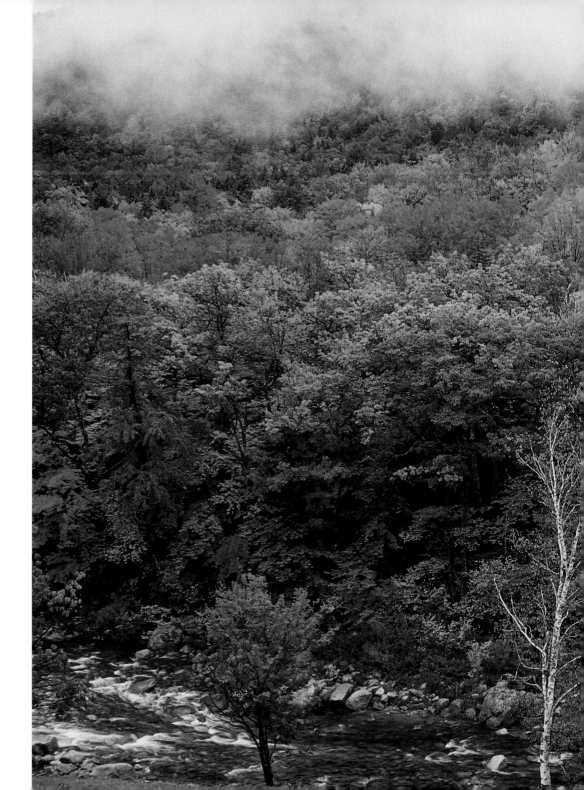

*White birch and
hardwoods,
Kancamagus
Highway, New
Hampshire*

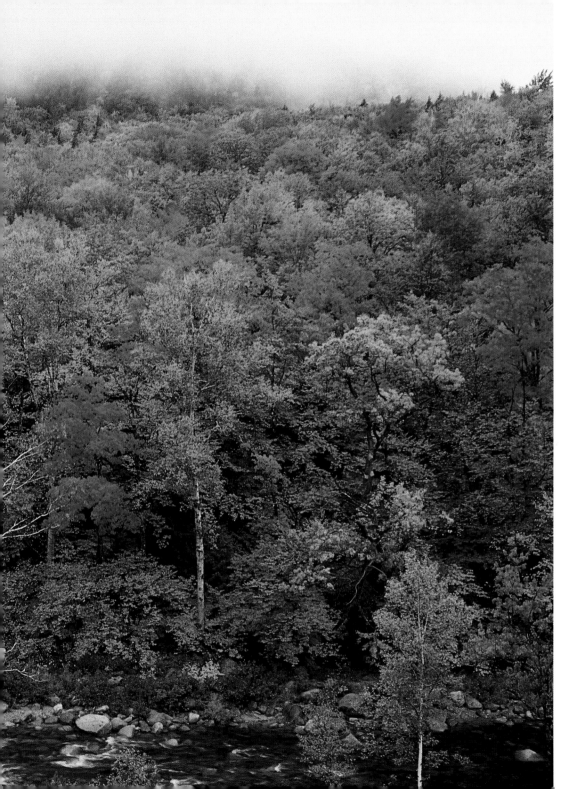

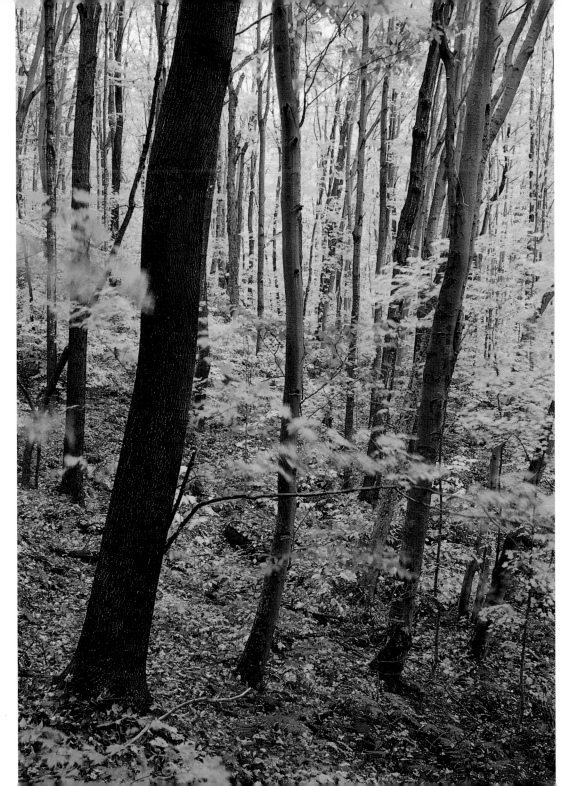

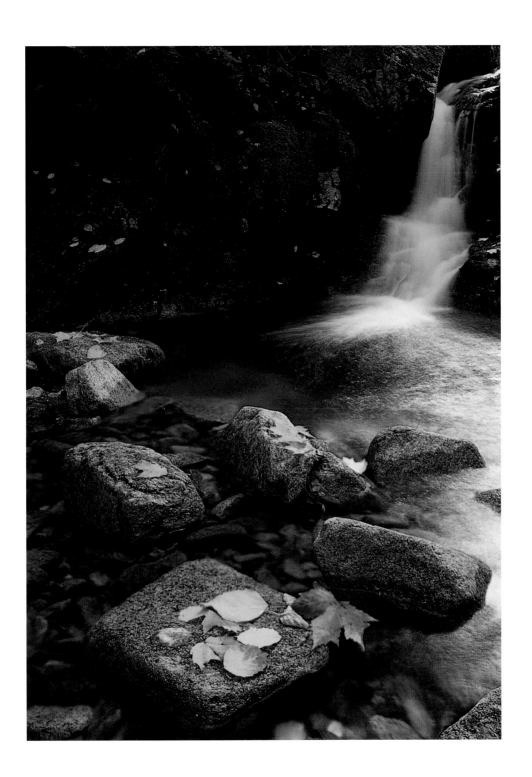

LEFT

*Waterfall, Cadillac
Mountain, Acadia
National Park,
Maine*

OPPOSITE

*After peak,
White Mountains,
New Hampshire*

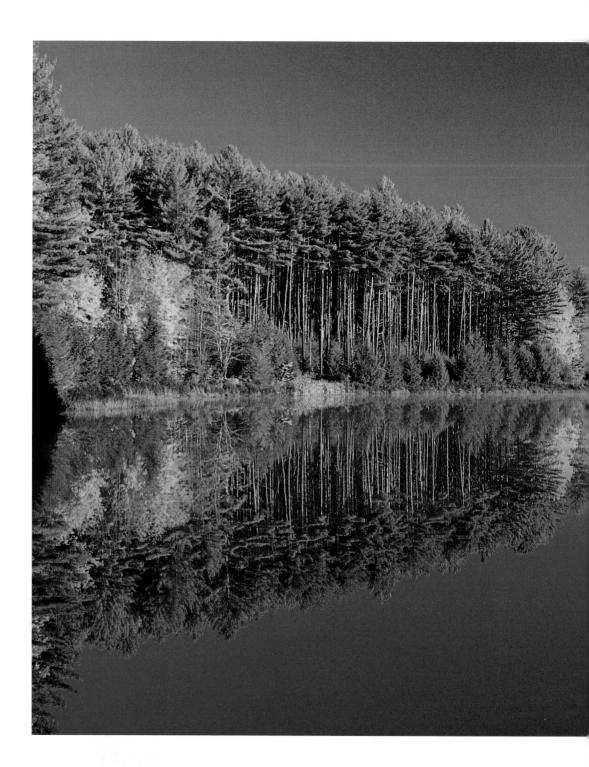

Stillwater

reflections

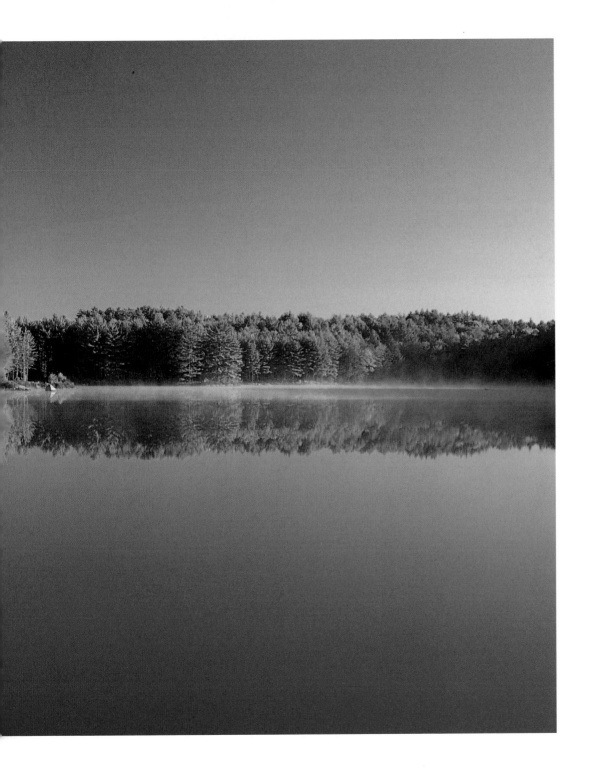

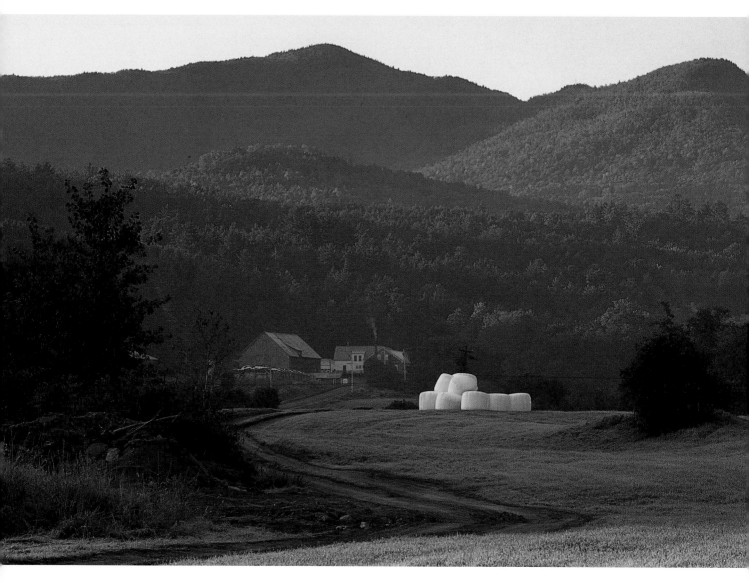

*Black spruce
above treeline,
Mount Madison,
New Hampshire*

*Waitsfield,
Vermont*

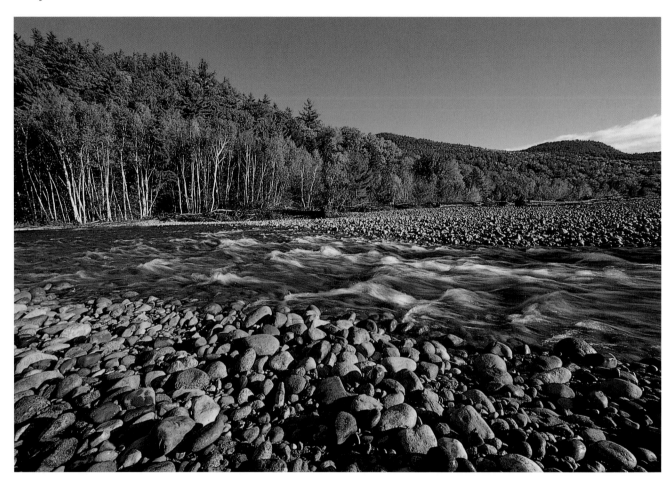

*Cobblestones and
birch trees,
Saco River, New
Hampshire*

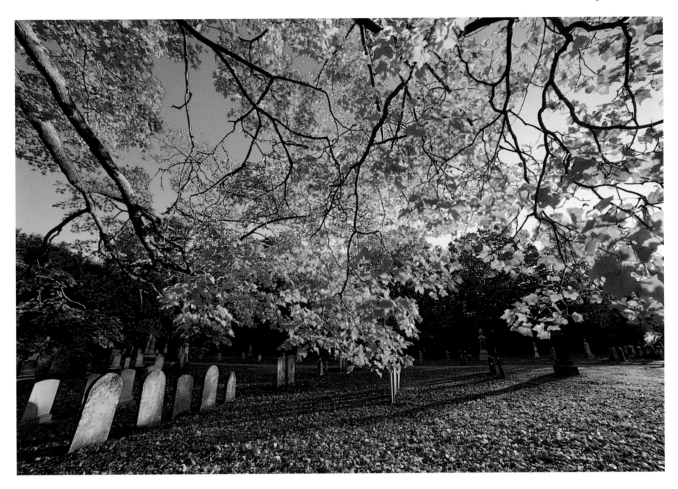

Sugar maples,

Portsmouth,

New Hampshire

THE COLOR OF LEAVES

LL TREES, whether deciduous or evergreen, share one thing in common: they all use a chemical called chlorophyll to transform sunlight, water, and carbon dioxide into glucose, a type of sugar, through a process known as photosynthesis. This sugar provides trees with the energy they need to survive, and it is primarily created in a tree's leaves. Trees are green for the simple fact that chlorophyll is green and there is so much chlorophyll in a tree's leaves that the green hides the other pigments that are present. At some point in late August or early September as daylight wanes, other chemicals in the leaves, primarily phytochrome, signal to the tree that winter is on its way. Nutrients move from the leaves to other parts of the tree for winter storage, and chlorophyll production slows.

By late September or early October, the remaining chlorophyll in leaves breaks down and the color change begins. As summer's green drains from the leaves, the yellow, orange, red, and purple of other pigments become more prominent. Yellows and oranges come from carotene and xanthophyll, chemicals that trap light as well as protect chlorophyll from the bleaching properties of sunlight. The deeper reds and purples are present in anthocyanin, a chemical more commonly used by plants to attract pollinators to flowers. Flavonol, a chemical related to anthocyanin, is also present in leaves, but it is usually colorless. However, under certain fall conditions, when sugars build up in a leaf, sugar molecules attach to flavonol, effectively turning them into brilliant red anthocyanin. The browns found in leaves are the result of a waste product known as tannin.

Predicting the exact time of peak colors is an unscientific and inaccurate exercise. In general, you can expect that there will be peak color somewhere in New England during the first two weeks of October. Beyond that, foliage pre-

dictions are about as accurate as a five-day weather forecast. Predicting the intensity of fall colors is also difficult, although the combination of sunny days and cold nights just as the leaves are turning seems to be a reliable predictor of more intense reds. These conditions allow sugar to build up in the leaves, increasing the amount of anthocyanins. However, even this relatively reliable indicator can falter due to unfavorable weather conditions in earlier parts of the growing season.

More predictable is the fact that rain and wind will knock leaves from their trees soon after fall colors peak (although beech trees and certain oaks tend to hold their leaves through winter). At the same time that chlorophyll production stops, a tree will begin to seal off the leaf from the rest of the tree at the base of the leaf stem. Once this seal is complete, the cells at the base of the leaf weaken, and eventually the leaf falls from the tree. When this happens, fall's color display moves from the forest canopy to the forest floor. For a few wonderful days each fall, hiking trails and woods roads become carpeted in red and gold, but soon these carpets turn to brown. By this time, the trees are prepared for winter, the tourists have gone home, and the quiet of winter descends on New England's forests.

OPPOSITE

Frost on maple
leaf, grass, and
corn stalk,
Vermont

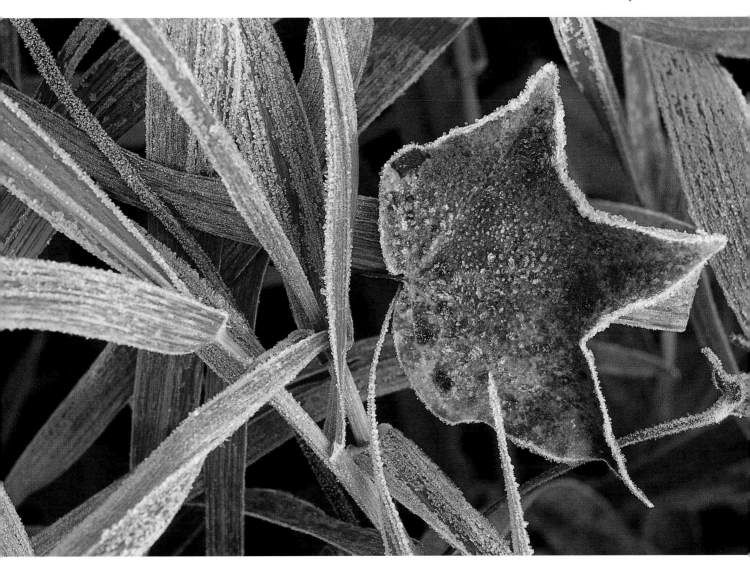

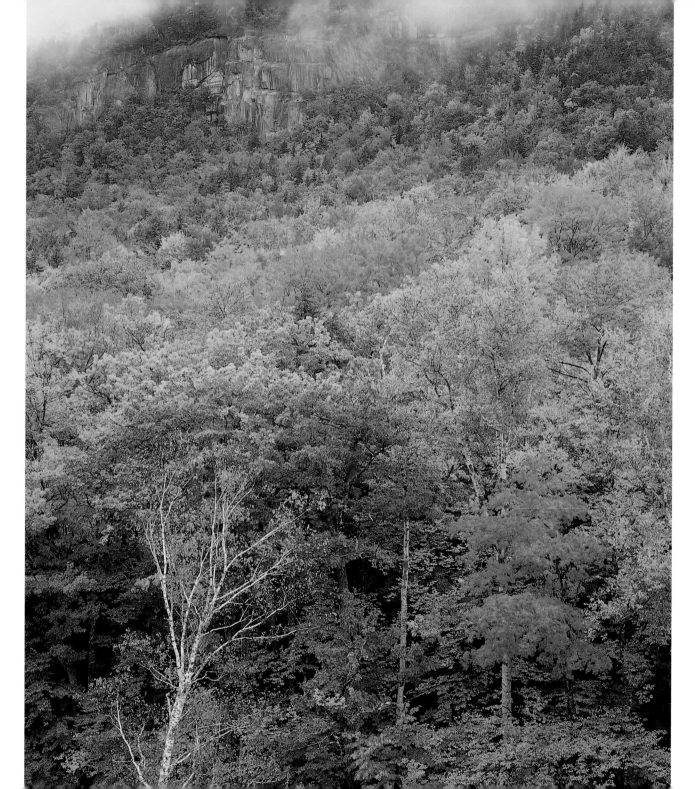

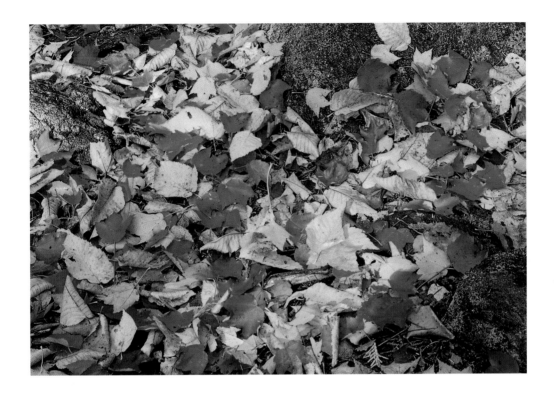

LEFT

Forest floor,

Maine

OPPOSITE

White birch and

hardwoods,

Kancamagus

Highway, New

Hampshire

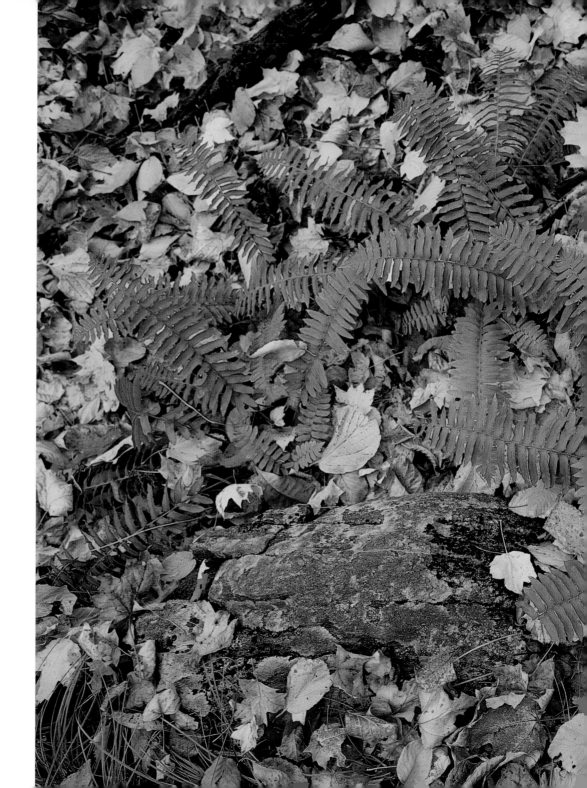

Common polypody,

Connecticut

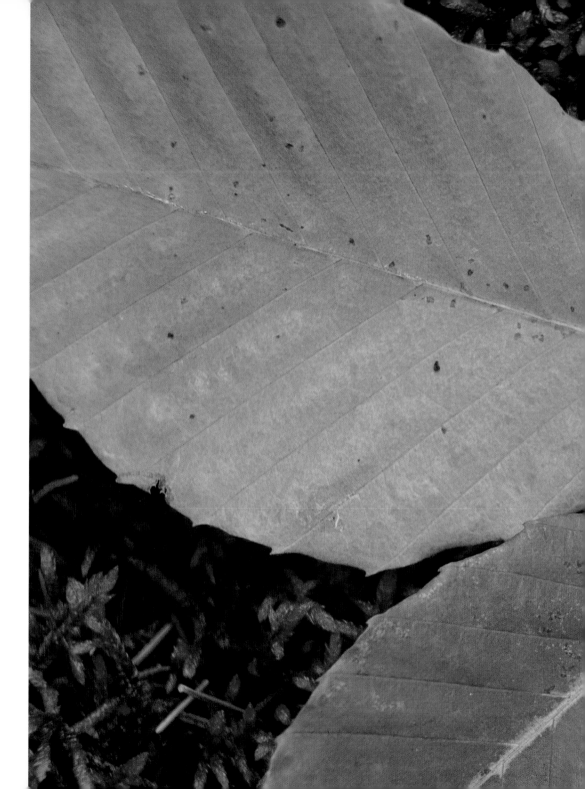

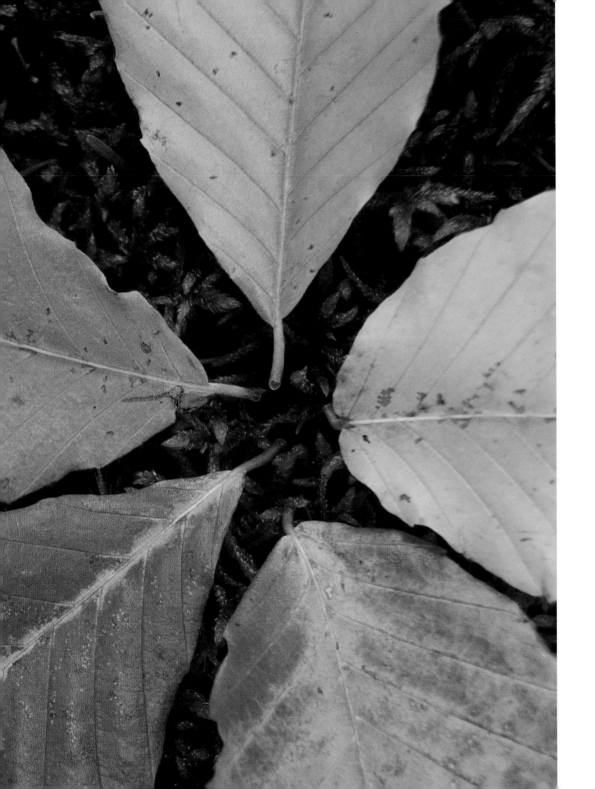

American beech

leaves

RIGHT

Lowbush blueberry
and lichen, Puzzle
Mountain, Maine

OPPOSITE

Black Cat
Mountain, Baxter
State Park, Maine

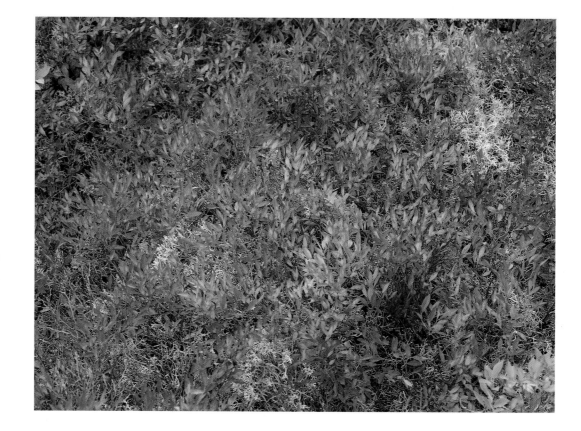

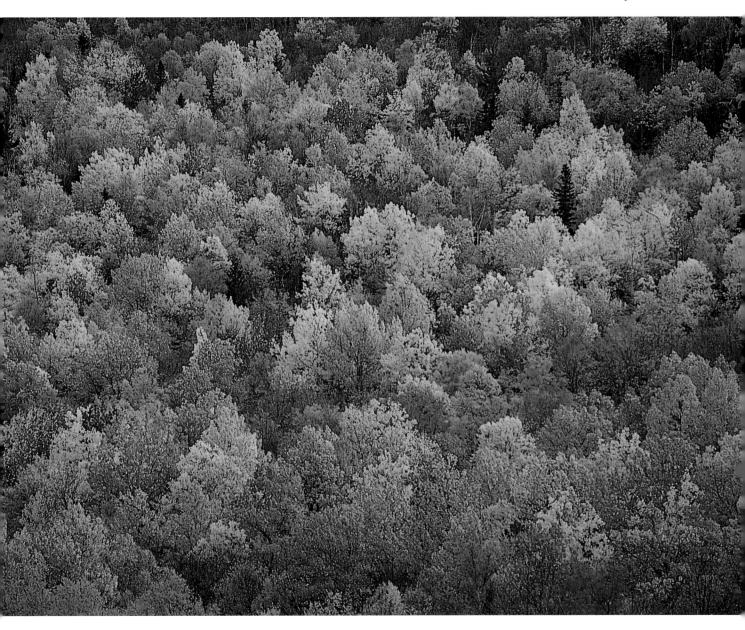

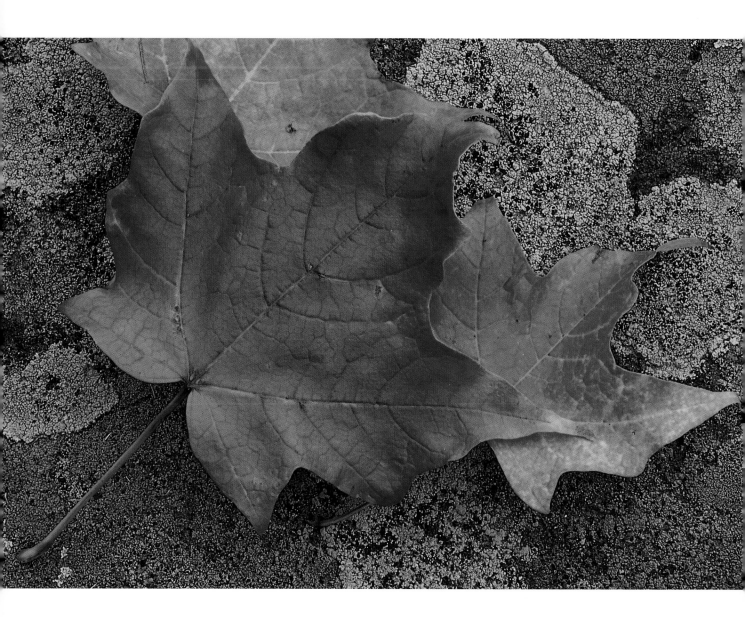

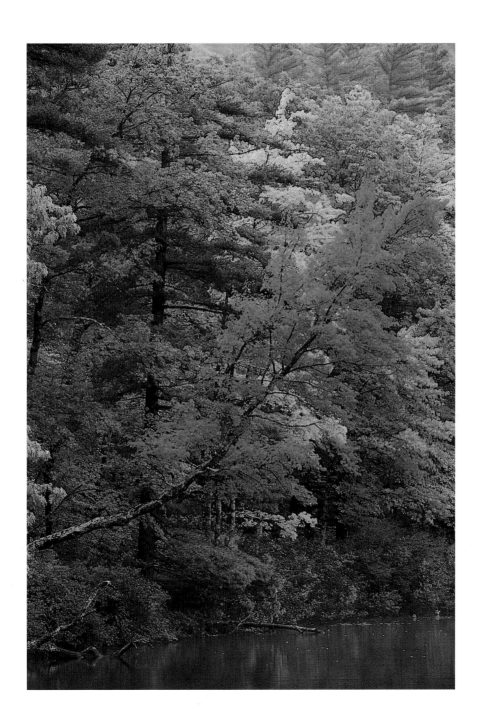

Saco River, White

Mountains, New

Hampshire

OPPOSITE

Sugar maple

leaves and lichen

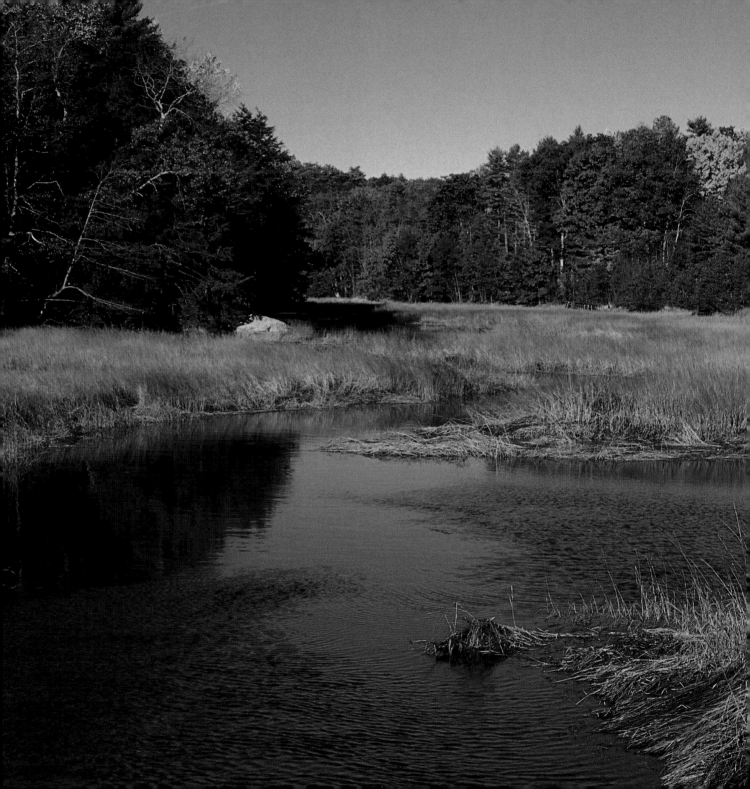

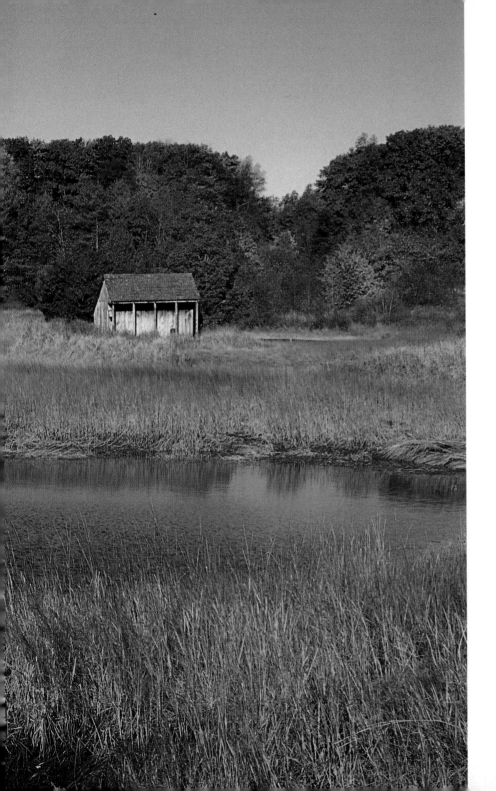

Tidal creek,

Durham, New

Hampshire

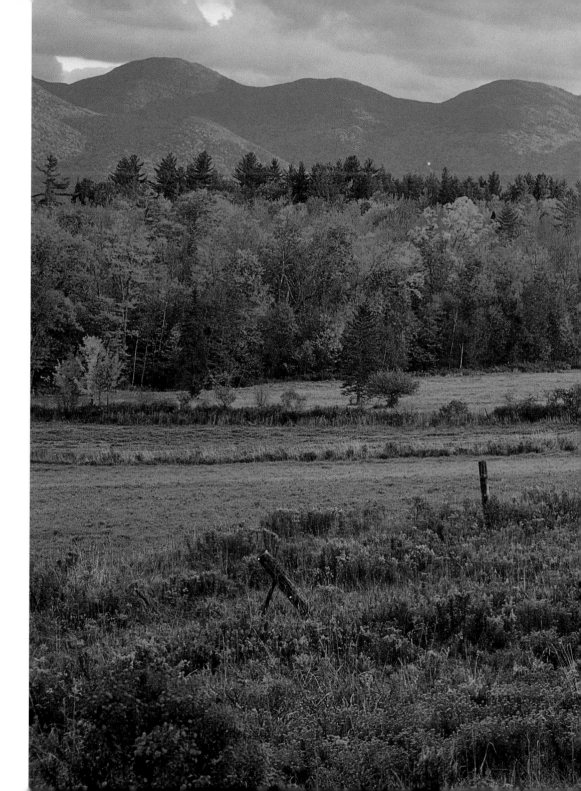

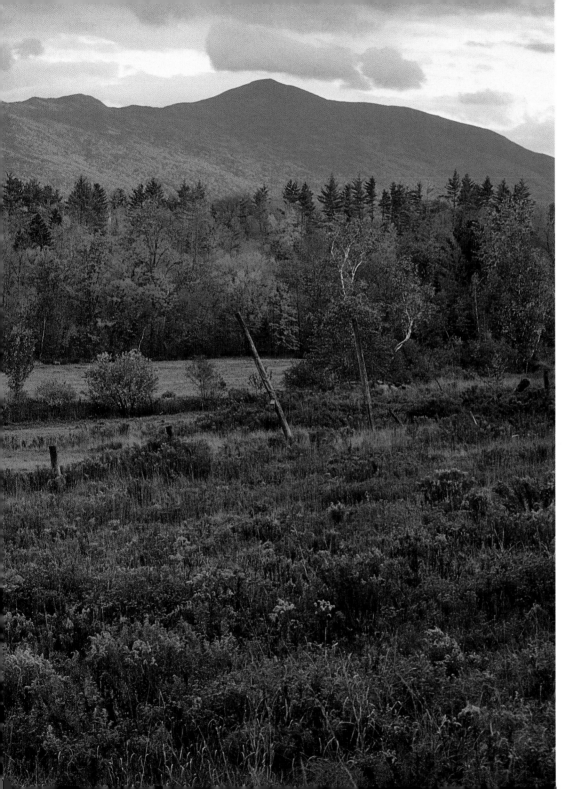

LEFT

*The Cannon Balls
and Kinsman
Mountain, New
Hampshire*

FOLLOWING PAGE

*Sand Beach and
the Beehive,
Acadia National
Park, Maine*

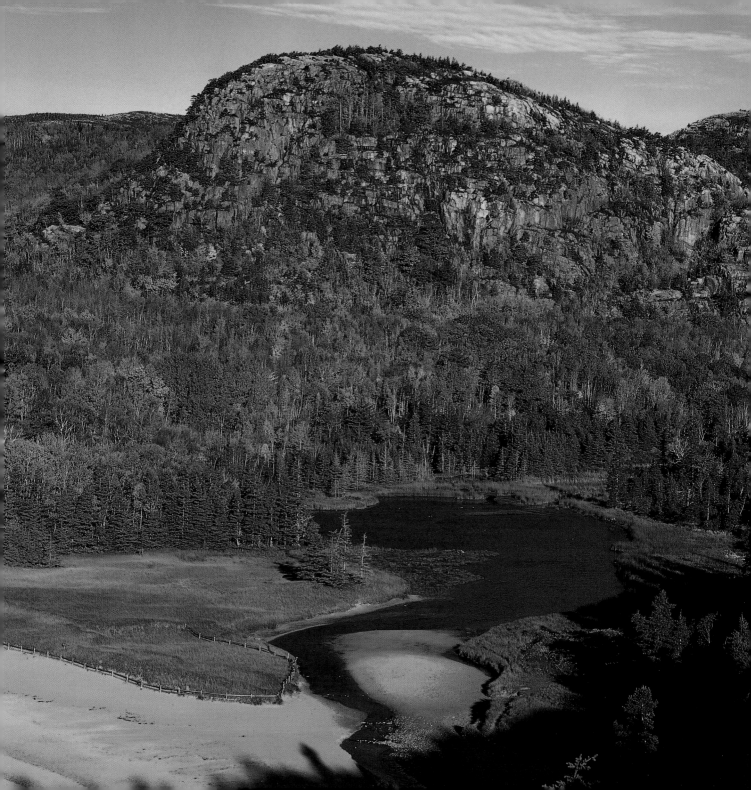

Suggested
Routes

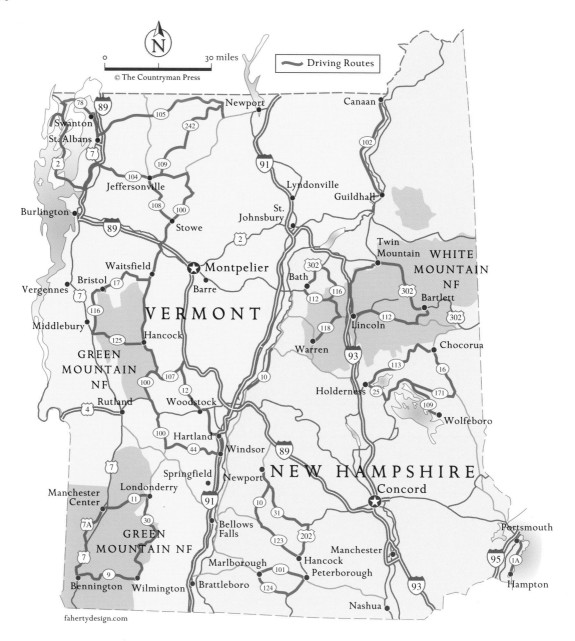

N

30 miles

© The Countryman Press

Driving Routes

Swanton

St. Albans

Newport

Canaan

78

89

105

242

102

7

2

91

104

109

Lyndonville

Jeffersonville

Guildhall

108

100

Twin

Mountain

WHITE

MOUNTAIN

NF

Burlington

89

Stowe

St.

Johnsbury

2

302

Bath

302

Bartlett

Waitsfield

Montpelier

116

Bristol

17

Barre

112

302

Vergennes

7

Lincoln

112

116

Chocorua

Middlebury

125

Hancock

118

113

16

GREEN

MOUNTAIN

NF

Warren

93

171

107

12

Holderness

109

100

Rutland

Woodstock

25

Wolfeboro

4

Hartland

100

44

Windsor

89

Springfield

NEW HAMPSHIRE

Concord

Newport

Manchester

Center

Londonderry

91

10

Portsmouth

11

31

7A

30

Bellows

Falls

202

95

7

GREEN

MOUNTAIN NF

123

Manchester

Hancock

Peterborough

1A

Marlborough

101

9

Bennington

Wilmington

Brattleboro

124

Hampton

Nashua

93

fahertydesign.com

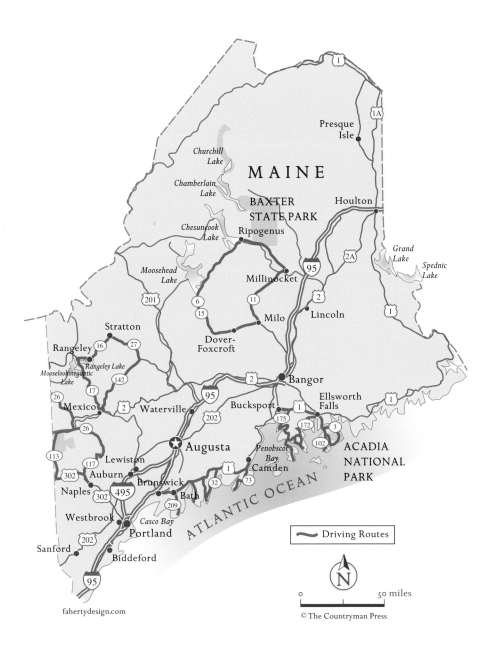

MAINE

Churchill
Lake

Chamberlain
Lake

BAXTER
STATE PARK

Chesuncook
Lake

Ripogenus

Moosehead
Lake

Presque
Isle

Houlton

Grand
Lake

Spednic
Lake

Millinocket

Milo

Lincoln

Stratton

Rangeley

Rangeley Lake

Mooselookmeguntic
Lake

Dover-
Foxcroft

Mexico

Waterville

Bucksport

Bangor

Ellsworth
Falls

Augusta

Penobscot
Bay

Camden

ACADIA
NATIONAL
PARK

Lewiston

Auburn

Brunswick

Naples

Bath

Westbrook

Casco Bay

Portland

Sanford

Biddeford

ATLANTIC OCEAN

Driving Routes

N

0 50 miles

© The Countryman Press

fahertydesign.com

95

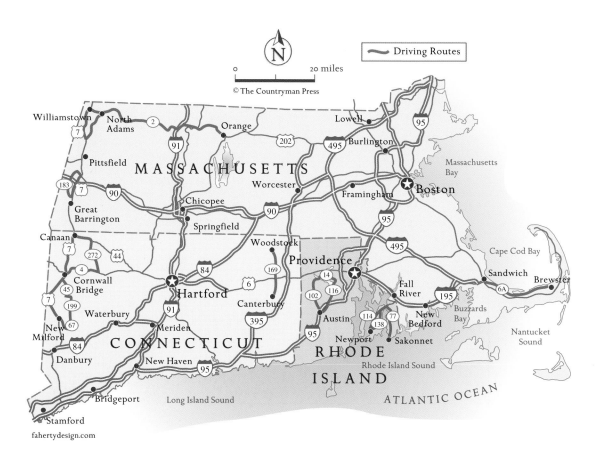